**Lucky Hans and Other Merz Fairy Tales** ■

ODDLY MODERN FAIRY TALES

Jack Zipes, *Series Editor*

# KURT SCHWITTERS
# LUCKY HANS
## AND OTHER **MERZ** FAIRY TALES

TRANSLATED AND
INTRODUCED BY
**JACK ZIPES**
ILLUSTRATED BY
**IRVINE PEACOCK**

PRINCETON UNIVERSITY PRESS   *Princeton and Oxford*

Copyright © 2009 by Princeton University Press

Published by Princeton University Press, 41 William Street,
Princeton, New Jersey 08540

In the United Kingdom:
Princeton University Press, 6 Oxford Street,
Woodstock, Oxfordshire OX20 1TW

The Library of Congress has cataloged the cloth edition of this book as follows

Schwitters, Kurt, 1887–1948.
    Selections. English. 2009]
    Lucky Hans and other Merz fairy tales / Kurt Schwitters ; translated
and introduced by Jack Zipes ; illustrated by Irvine Peacock.
       p.    cm.
    Translation of selections from: Der glückliche Hans and Merz.
    Includes bibliographical references.
    ISBN 978-0-691-13967-8 (hardcover : alk. paper)   1. Schwitters, Kurt,
1887–1948—Translations into English.   2. Schwitters, Kurt, 1887–1948.
Glückliche Hans. English.   3. Schwitters, Kurt, 1887–1948. Merz. Eng-
lish.   I. Peacock, Irvine.   II. Title.
    PT2638.W896A2 2009
    833'.912—dc22                                          2008024836

ISBN 978-0-691-13967-8

British Library Cataloging-in-Publication Data is available
This book has been composed in Minion Pro
Printed on acid-free paper. ∞
press.princeton.edu
Printed in the United States of America

10  9  8  7  6  5  4  3  2

*To my daughter Hanna*

*With Love*

# Contents

Translator's Note and Acknowledgments    xi

Kurt Schwitters, Politics, and the Merz Fairy Tale    1

## Tales Written in German

1 The Swineherd and the Great, Illustrious Writer    41
*Der Schweinehirt und der Dichterfürst (1925)*

2 Lucky Hans    49
*Der glückliche Hans (1925)*

3 Happiness    57
*Das Glück (1925)*

4 The Little Clock Spirit and the Lovers    61
*Uhrgeistchen und Liebespaar (1925)*

5 The Proud Young Woman    63
*Das stolze Mädchen (1925)*

6 An Old Fairy Tale    67
*Altes Märchen (1925)*

7 The Scarecrow    72
*Die Scheuche (1925)—A children's book created
with Kate Steinitz and Theo van Doesburg*

**8** He  85
*Er (1927)*

**9** Fish and Man  103
*Fisch und Mensch (1927)*

**10** The Squinting Doll  105
*Die schielende Puppe (1927)*

**11** Three Suitcases  107
*Drei Koffer (1927)*

**12** Fairy Tale  115
*Märchen (1928)*

**13** A King without People  116
*König ohne Volk (1932)*

**14** The Story about the Good Man  119
*Die Fabel vom guten Menschen (1933)*

**15** Happy Country  121
*Glückliches Land (1933)*

**16** The Story about the Rabbit  123
*Die Geschichte vom Hasen (1934)*

**17** The Three Wishes  125
*Die drei Wünsche (1936)*

**18** The Ugly Young Woman: A Fairy Tale  131
*Das häßliche Mädchen: Ein Märchen (1937)*

.

**19** The Two Brothers   137
*Die beiden Brüder (1938)*

**20** The Fish and the Ship's Propeller   143
*Der Fisch und die Schiffsschraube (1938)*

**21** Transformations   145
*Verwandlungen (1938)*

**22** He Who Is Mentally Retarded   153
*Der, der da geistig arm ist (1938)*

**23** Hans and Grete: A Fairy Tale about
Children Who Live in the Woods   161
*Hans und Grete: Märchen von Kindern, die im Walde wohnen (1939)*

**24** The Fairy Tale about Happiness   165
*Das Märchen vom Glück (1930–1940)*

**25** Normal Insanity   169
*Normaler Unsinn (1930–1940)*

**26** What Is Happiness   173
*Was ist das Glück (1940–1945)*

**27** The Man with the Glass Nose   179
*Der Mann mit dem gläsernen Nase (1945)*

**28** Once upon a Time There Was a Tiny Mouse   183
*Es war einmal eine kleine Maus (1941–1946)*

## Tales Written in English

**29** The Flat and the Round Painter   189
*(1941)*

**30** London: A Fairy Tale   193
*(1942)*

**31** The Flying Fish   197
*(1944)*

**32** Twopenny Novel about an Ugly Girl   203
*(1941–1945)*

Appendix: German Version of "Die Scheuche"   207

Notes   221

Bibliography   233

## Translator's Note and Acknowledgments

The fairy tales translated in this book were originally published in 1973–1974 by DuMont Verlag in Cologne. They appear in Kurt Schwitters, *Das literarische Werk*, volume 1: *Prosa 1918–1930* and volume 2: *Prosa 1931–1948*, edited by Friedhelm Lach. It is thanks to Lach's dedicated and meticulous research that Schwitters's prose, poetry, critical writings, and dramas have become accessible to a large public in Germany. Schwitters's fairy tales, however, have never been organized into one volume before, neither in German nor in English. I have selected all those tales that I consider to be fairy tales from the stories and grotesques Lach collected from Schwitters's published works and unpublished manuscripts.

Sometimes it is difficult to discern what might rightly be called a fairy tale or a grotesque, for many of Schwitters's fairy tales seem to be grotesques and vice versa. To give one example, Schwitters wrote a grotesque called "Unser Baby, der Elefant" ("Our Baby, the Elephant," 1926/27) that I might have included as a fairy tale. It is told in a first-person colloquial form by a young man, who is a poor and seemingly unemployed pianist. He and his wife have not been able to have a baby after eleven years of marriage and have not paid the rent for their apartment for eleven years. The narrator's name is Finger, and he has a friend named Klapperstorch (the stork who brings babies), and this friend, called Klap for short, brings them an elephant for a baby out of the goodness

of his heart. At first the landlord is angry, but he gradually becomes accustomed to the elephant, and one day, when the enormous animal gives birth to twenty-five little elephants, he convinces Finger and his wife to give all the elephants to him by cancelling their debts and returning a piano to Finger. After they do this, the landlord has the elephants slaughtered to make their meat into sausages. Finger and his wife decide to go to the zoo and bring back a lion for their next baby.

Though there are fairy-tale motifs in this tale, such as the couple who wish to have a child and end up with a beast, the dominant form and tone of the tale depend on grotesque exaggeration and macabre events that evoke revulsion. The grotesque as a short story was very popular in Germany during the 1920s because it enabled many writers to exhibit their disgust with the conditions in the Weimar Republic. Schwitters's tale comes closer to Kafka's bizarre stories or what we might call magical realism today. Therefore, I chose not to include "Our Baby, the Elephant" in this collection, but I do want to suggest that there are many other of Schwitters's grotesques and prose narratives that are closely connected to his experiments with fairy tales. In short, all his works—his collages, paintings, poetry, plays, songs—are intertwined and often shed light on each other.

With the exception of two of Schwitters's unusual fairy tales for children, *Hahnepeter* (*Peter the Rooster*, 1924) and *Die Märchen vom Paradies* (*The Fairy Tales of Paradise*, 1924/25), I believe that the tales in this volume constitute all

the fairy tales Schwitters ever wrote. Strangely, he never published anything about his concept of fairy tales. They speak for themselves. They are, in this respect, truly Merz.

In developing this project, I was greatly assisted and encouraged by the graphic artist Barrie Tullett of Caseroom Press, who re-created Schwitters's typology of "The Scarecrow" for me, and by the gifted artist Irvine Peacock, who provided the remarkable illustrations for this volume. I think that Schwitters would have approved of our creative collaboration. In addition to Barrie and Irvine, I want to thank the anonymous reviewers who made many important critical suggestions.

Throughout the production process, Sara Lerner was always there for me and supervised the complex collaboration of all the participants in the project with great care and efficiency. Kim Hastings was a fabulous and meticulous copyeditor, catching many inconsistencies and tuning in perfectly to Schwitters's wry humor and style. Patrizia McBride provided very helpful comments regarding my introduction just when I needed them. As usual, my wife, Carol Dines, took every step I have taken with Schwitters and read many drafts of the tales with smiles and insightful criticism. Last but not least, I cannot thank Hanne Winarsky enough for her enthusiastic support and tireless dedication to this project. Without Hanne, the book would not have come to fruition.

Jack Zipes, Minneapolis
May 10, 2008

**Lucky Hans and Other Merz Fairy Tales** ■

## Kurt Schwitters, Politics, and the Merz Fairy Tale

The word "Merz" had no meaning when I formed it. Now it has
the meaning that I have attached to it. The meaning of the
concept "Merz" changes as the understanding of the person who
continues to work with it changes.

 Merz wants freedom from all fetters in order to shape things
artistically. Freedom is not unrestraint, but rather the result
of strict artistic discipline. Merz also means tolerance toward
any kind of limitation for artistic reasons. Every artist must be
permitted to compose a picture, even if it is just made out of
blotting paper, provided that he knows how to create.

—Kurt Schwitters, "Merz," 1920

Merz is the smile at the grave and seriousness on cheerful
occasions.

—Kurt Schwitters, *Merzbuch 1*, 1926

Long before the term "fractured fairy tale" came into use,
Kurt Schwitters had turned the fairy tale upside down and
inside out. Little is known about his subversive work as a
fairy-tale writer, mainly because very few of the tales were
published during his lifetime. And, even with the publica-
tion of his complete writings by DuMont Verlag, along with
many important scholarly studies of his literary work from
1974 to the present, very little attention has been paid to his
innovations in the fairy-tale genre and how his tales relate to

his other Merz projects and to the radical fairy-tale work in Germany, especially during the 1920s.

Schwitters had a scurrilous imagination and constantly sought to stretch the borders and forms of art beyond recognition. He delighted in breaking rules and conventions to free the mind. In particular, his fairy tales, which he wrote continually throughout his life, were intended to provoke readers to think outside those socially constructed boxes that, Schwitters felt, constrained the creative potential and temperament of every individual. Unfortunately, most of his unusual tales never reached a large reading public and were never collected and published as a separate book. Gathered together now in this present collection, for the first time, they enable us to see how seriously he was engaged with the fairy-tale genre and how he used his tales as aesthetic experiments to convey his wry philosophical and political comments about the illusion of happiness and the need for constant transformation. As an artist, he had greater success and achieved "notoriety" with his poetry, montage work, and theatrical performances. For a while he even achieved international celebrity. Yet, despite this success and his strenuous efforts to promote his art works and theories, he always felt marginalized, and it was from the margins that he created all his Merz art, including his provocative fairy tales that continue to speak to us today.

Schwitters, the artist as rebel and odd man out, was perhaps an unlikely candidate for the role of provocateur. And indeed, there was something bizarre about his double life: he

was a demure solid bourgeois gentleman, who loved to dwell at home, and an impulsive radical artist, totally dedicated to his concept of Merz, who traveled about to startle audiences and challenge their "normal" views of life and art. "Merz is a way of viewing the world," Schwitters declared in 1924. "Its essence is absolute uninhibitedness. This is the basis for creation in the meaning of Merz. There are never any inhibitions for the artist in the moment of creation."[1]

## The Bourgeois as Rebel

Dada artists such as George Grosz and Richard Huelsenbeck took painting, sculpture, collage, and modernist poetry—in a word, "Modernism"—at its word.

They insisted that *any*, however violated, adherence to the formal codes salient to those practices necessarily signified an allegiance to Western bourgeois discourses, politics, and values. As such, Schwitters' eccentric deployment and manipulation of Modernist pictorial codes, such as the relationship between line and color, entailed an inevitable rejection from "club Dada."

—Jaleh Mansoor, "Kurt Schwitters' Merzbau: The Desiring House"

I am a painter and I nail my pictures together.

—Kurt Schwitters, quoted in Hans Richter, *Dada Art and Anti-Art*

Born in Hannover, an industrial and snug conservative German city, Schwitters was the only son of a well-to-do middle-class family that provided him with the stability and leisure

he needed to pursue all his artistic interests.[2] Though he was strongly attached to his parents and to Hannover, he had a very ironic view of his family background and hometown, as his brief curriculum vitae, written in 1920/21, reveals:

Grandparents Beckemeyer, Hannover. Carpenter. Very solid bourgeois, simple. Grandfather epileptic. Grandmother knew how to make gold out of straw. Thrifty. Only five children. My mother Henriette began earning money very early. As soon as she turned thirteen, she began sewing for a fashionable clothing shop that she managed when she turned seventeen. Very talented musically, poor teeth. She owned her own fashionable clothing shop when she was twenty-one.

Grandfather Schwitters in East Friesland, shoemaker, violent temper. Grandmother Schwitters died early. Second wife. So then, my father had a stepmother. Five brothers and sisters. My father, typhoid fever, apprentice, worked in the clothing business. He specialized in decoration. 1886 own store in Hannover, poor teeth.

I myself was born on June 20, 1887, in Hannover, Veilchen Straße or Violet Street (The Land of Violets). My wet nurse had milk that was too thick and too little. Since she had to feed me beyond the time legally allowed for breast-feeding, she was punished. So, I learned about the evils of the world early through close corporeal experiences. The core of my being, melancholy. Lived in

Hannover (Revon) until 1909 except for all kinds of trips all about. I called myself Kuwitter, wet my pants, and was locked up in the bathroom. Easter 1894 I went to school, then Realgymnasium I. Hannover. So-called gifted student. My grades were low, with the exception of drawing and writing. I enjoyed school. I can't say otherwise. . . . Two years sick [epilepsy], completely unable to work. My interests changed due to the sickness. I realized that I had a love for art. In the beginning I composed couplets in the manner of the variety comedians. On a fall evening with a full moon I was struck by the clear cold moon. From that time on, I began writing sentimental lyrics. Then music seemed to be the art for me. I learned how to read notes and played music the entire afternoon. 1906 I saw a moonlit landscape for the first time in Isernhagen, and I began to paint. 100 aquarelle moonlit, naturalistic landscapes. With stearin candle for lighting. I decided to become a painter. The usual objection of parents. First you graduate high school, then you can have our permission. Alongside regular studies I took classes at the school of arts and crafts and gradually became academic. Easter 1908 high school exams and graduation. As we formed a line for graduation, one of my fellow students, Harmening, said, "Don't let the melancholy Schwitters go ahead of us. Otherwise, our march to the podium will resemble a funeral procession."[3]

Though tongue-in-cheek and exaggerated, most of what Schwitters wrote is true. In fact, early in his childhood his parents had occupied a house on Violet Street and then moved to a larger and more comfortable one on Waldhausenstrasse, where Schwitters spent most of his life. (Even after he married Helma Fischer, in 1915, he remained with her in this house until 1937.) As a child, he suffered from epilepsy, which continued to plague him as an adult; despite epileptic attacks that caused him to withdraw from society in his youth, he gradually came out of his shell as he began to study art in Hannover and Dresden after his graduation from high school.

From 1909 until 1919, Schwitters was a serious and, at first, conventional student of painting and architecture at the College of Art in Dresden. During this time, his parents provided him with the financial support he needed. They had retired from the clothing business and lived off the income of four other houses that they had bought in Hannover. Therefore, Schwitters was able to receive a thorough education in all branches of art; he was well trained in landscape and portrait painting, mastered the formal techniques of drawing, and appeared to be heading toward a traditional career as either painter or architect. He eventually became an expert typographer. His life with Helma Fischer was also traditional; she occupied herself with the household and his affairs, while he studied and traveled about. In 1919, they had a son, Ernst, an only child, just as Schwitters had been. However, the orderly surface of the Schwitters family was just ve-

neer, for Schwitters had always felt an impulse to play with conventions and rules—not only in public but in his own home, where he built Merz environments.

As early as 1914, with the outbreak of World War I and the great changes that ensued in Germany, Schwitters began to re-evaluate his attitudes toward art and society. His artistic inclinations had always made him sensitive to authoritarian rule, and his liberal attitudes grew as he realized how the monarchical regime manipulated the German people and caused great misery and catastrophes. Gradually, as was the case with many intellectuals and artists of his class, the wartime experiences and protests by expressionist and Dadaist painters led him to become a quiet critic of the very bourgeois conservatism that harbored him and to begin his own private rebellion as an artist. Though he never participated in political movements and parties, Schwitters was temperamentally a revolutionary, always seeking to question and upset the established views of society, art, and government. He was against the war and despised nationalism of any kind. During the war years, he was at first allowed to continue his art studies in Dresden, where he became increasingly aware of the expressionist, futurist, cubist, and Dadaist experiments. By 1917, however, he had to interrupt his studies because he was drafted by the military and worked at a desk job in Hannover for several months. After persistently annoying his superiors, he was discharged from the army and assigned a job as a mechanical draftsman in the Wülfel ironworks outside Hannover. During this time,

he continued to write poetry and experiment with collage and montage paintings.

By 1918, Schwitters had abandoned all interest in traditional art forms and sought to create something new out of the ruins of the war. Vast cultural and political changes throughout Germany had a great impact on his life, even in the conservative city of Hannover. For instance, he began participating in the activities of the Kestner Society, an independent cultural club founded in 1916 to introduce programs and organize exhibits about new tendencies in art and literature for the educated bourgeois public in Hannover. It was in this society, from 1919 through the early 1930s, that Schwitters learned a great deal about avant-garde literature, expressionism, futurism, constructivism, and surrealism, and it was there that he read his own stories, organized Merz events, and prepared special programs. Though not an active participant in the antiwar movement, he felt liberated by the revolutions of 1918 and 1919. He started traveling to Berlin, where he began associating with Herwarth Walden, the leader of the *Sturm* circle, a loose group of expressionists who broke with conventional painting and writing and produced some of the most significant artworks of the 1920s. Their journal, *Der Sturm,* was an important publication that carried their political declarations, poetry, stories, and other writings. Schwitters began publishing in *Der Sturm* as early as 1918, and in Hannover, thanks to Walden, Schwitters made contact with progressive intellectuals and artists who founded such journals as *Der Zweemann* and *Die Pille.* By 1919, Schwitters became a contributor to

both magazines and formed a close friendship with Christof Spengemann, the editor of *Der Zweemann* and a left-leaning art critic and social democrat.

Schwitters was literally carried away by all the experimental movements in the arts and, like a sponge, he sought to absorb every innovative element generated by radical painters and writers. When he tried to join the Berlin Dadaists, however, he was rejected because his work was not explicitly political, and he appeared to be suspicious in their eyes. Richard Huelsenbeck, the leader of the Berlin Dadaists, regarded Schwitters's dress and behavior as petty bourgeois, and George Grosz disdained him for not declaring his allegiance to engaged political art. But Schwitters was not to be denied. He felt a strong affinity with the work of Dadaist artists and writers and began very early in his writing and painting to move away from the outpourings of the expressionists. Since he could not "officially" call himself a Dadaist, however, he had to find a special name for his new collages and assemblages.

Consequently, he invented Merz, which was the designation he used for the unusual collages, montages, and environments that he began creating out of rubbish and found objects. The term was formed almost by chance from the name *Kommerzbank* and combined the connotation of "commerce" with that of the verb *ausmerzen*, "to eradicate or annihilate." Schwitters sought to rub out vapid traditional forms, rules, and order and make new sense out of ordinary objects that had survived the destructive tendencies of warmongers. In many ways, he re-utilized material objects and

re-formed them to question their use and alleged meaning. If there was sense to life after the end of World War I in 1918, he believed that it was nonsense, for reason had been corrupted and distorted by the cultural and political leaders of the Wilhelminian Empire. Schwitters was fascinated by the common and ordinary artifacts of life that had been ordered by arbitrary social laws and codes, and suggested through his collages that they might be reordered and recomposed to expose the contradictions of imposed forms and laws. Most of all, he reacted against inhibition and the instrumentalization of the imagination, almost as if he were reacting against the stuffy claustrophobic atmosphere of provincial Hannover.

It is important to stress that although Schwitters continued to use the term "Merz" throughout his life, the actual significance of this specific type of artwork covers the period from 1919 to 1922 and had much in common with the radical experiments of the Weimar period. As Friedhelm Lach has commented, "From a historical perspective Schwitters's different manifestos and statements clearly demonstrate the commonality of the Merz projects. Moreover, we must regard the Merz art in connection with the European art movements from the period before World War I to the stabilization of the society in the postwar period. The artists of this time understood themselves as revolutionaries, who wanted to break out of the confines and containment of the Wilhelminian forms of life. They strived to move beyond the narrow bourgeois-capitalist views to a new and universal openness."[4]

Even though Schwitters lacked the explicit political commitment that the Berlin Dadaists professed and demanded—and there was always tension between him and Huelsenbeck and Grosz—he did not abandon his "radical" campaign to democratize art and foster individual freedom. Merz art did not align itself with a particular political party or theory, but it clearly scrambled forms and laws to challenge viewers to shape their own ideas of what art was supposed to mean in light of the social and political conditions of his times. Yet it was not just through painting that Schwitters wanted to make his mark in the world of art, but also through literature, theater, and music. Following the 1919 publication of his famous poem "To Anna Bloom," which dealt with the triteness and banality of sentimental love, Schwitters became famous, if not notorious. It is strange nowadays to grasp why this poem caused such a sensation in Schwitters's time, but it evidently touched a nerve that remained electric during the Weimar period.

To Anna Bloom

Oh You, beloved of my 27 senses, to you I love!
You, yours, you to you, I to you, you to me,——we?
That (incidentally) is beside the point!

Who are you, uncounted lady, you are, are you?
People say, you are.
Let them say it, they don't know how things stand.

You wear your hat on your feet and meander on your
  hands,
On your hands you meander.

Hallo, your red dress, sliced in white pleats,
Red I love Anna Bloom, red to you I love.
You, yours, you to you, I to you, you to me,——we?
This belongs incidentally to the cold glow!
Anna Bloom, red Anna Bloom, what are the
  people saying?

*Prize question:*
  1) Anna Bloom has a screw loose.
  2) Anna Bloom is red.
  3) What color is the screw.

Blue is the color of your blonde hair.
Red is the color of your green screw.
You simple girl in your everyday dress,
You lovely green beast, to you my love!
You, yours, you to you, I to you, you to me,——we?
That belongs incidentally to the—glow box.

Anna Bloom, Anna, A — N — N — A!
I trickle your name.
Your name drips like soft tallow.
You know it, Anna, you already know it,
One can read you from behind.
And you, you most glorious of all,
You are from behind as from the front.

A — N— N — A
Tallow trickles STROKING my back.
Anna Bloom,
You dripping beast,
To You — I — love![5]

Conventional love is transformed into an unconventional
and ungrammatical declaration of babble, and from this
point on, Schwitters was to lead a conventionally ungram-
matical life. From 1919 until approximately 1930, Schwitters
collaborated with progressive groups in Hannover to orga-
nize shocking Merz events that prefigured contemporary
performance art. He also served as a manager of art exhibits
by avant-garde painters and writers and collaborated with
groups throughout Europe. Among his closest friends and
collaborators were some of the most important Dadaists of
the Weimar period; Raoul Hausmann, Hannah Höch, Hans
Arp, Tristan Tzara, and Katherine Dreier influenced him,
worked with him, or helped him produce shows and events.
Dreier, an American artist, was particularly important be-
cause she made Schwitters known in America. A member of
the group Abstract Création in New York, she studied paint-
ing in Paris, Munich, and London from 1907 to 1914. When
she returned to the States, she founded Société Anonyme in
New York with Marcel Duchamp and Francis Picabia to pro-
mote modern art, especially Dadaism, and to establish con-
tacts with avant-garde European painters. While traveling in
Europe in 1920, she discovered Schwitters's work and then

virtually became his patron-saint in America; she arranged for several showings of his collages from 1923 to 1942.

Schwitters himself traveled widely in Germany and Europe to exhibit his collages and paintings and to perform his poetry and other skits, often with music and impromptu recitals. Since his parents had lost most of their money due to the inflation that followed World War I, Schwitters had to earn his own keep and supported himself and his family by selling his collages, performing, and writing short articles or stories. To make ends meet—and Schwitters was always frugal—he published unusual fairy tales, grotesques, and poems in newspapers throughout the 1920s, and with his friends Kate Steinitz, a gifted artist who had moved with her husband to Hannover in 1914, and Theo van Doesburg, the brilliant founder of the De Stijl movement in the Netherlands, he tried producing children's fairy-tale books composed with unusual typography. The experimental publications they produced during this time were *Hahnepeter* (*Peter the Rooster*, 1924), *Die Märchen vom Paradies* (*The Fairy Tales of Paradise*, 1924/25), and *Die Scheuche* (*The Scarecrow*, 1925).

Schwitters had already been writing and reciting his fairy tales for adult audiences, and when Steinitz paid him a social call in 1924, he spontaneously began telling a children's story about Peter the Rooster. Steinitz recorded it with her typewriter and added illustrations, and he dedicated himself to the typography. By this time he had already attained a great command of typography owing to his interest in the futurists' experiments and his own inclination to explore the

meanings of letters and printed words. Schwitters wanted to liberate words and sounds and transform them on paper so that they could produce diverse meanings. He and Steinitz worked together to resolve problems of form and function in the use of type and image. The story itself was simple and concerned the boy Ernst, Schwitters's son, who wanted to visit Peter the rooster and the rooster man in paradise. Once they had published the story in Schwitters's Merz journal, which he had recently founded, and as a separate book, they decided to add a sequel, *The Fairy Tales of Paradise*, which was printed at their new publishing house, Aposs. Steinitz has explained how this strange name came about: "I worried lest the name Merz would become a sword that would pierce *Fairy Tales* and me and pin us both down. The Merz label would certainly prejudice teachers (not children) against these new fairy tales for our times. But, meanwhile, a wonderful new pressmark had occurred to us. It had to be used. 'Aposs'! A = active; P = paradox; OS = oppose sentimentality; S = sensitive. A wonderful motto! A useful umbrella for many occasions."[6]

No sooner had *The Fairy Tales of Paradise* been published than Theo van Doesburg and his wife, Nelly, arrived in Hannover, prompting Schwitters to produce another tale, "The Scarecrow." This time, all three—Steinitz, van Doesburg, and Schwitters—collaborated in a unique fashion: they employed only letters and different font sizes to create the illustrations. Fortunately, they also had the help of a gifted typesetter named Paul Vogt, who was able to adjust the forms and sizes

of the letters to fit the bizarre narrative. Though not written in verse, the letters create a rhythmic beat so that the tale reads like a poem. Of course, none of the three books sold well. The artists were way ahead of their times.

Without a good reception and the possibility to attract a public, Schwitters lost interest in these ventures and found that he would be better off by performing skits and stories, including fairy tales and grotesques, which were not published during his lifetime. He continued to paint and create unusual collages, lectured on art and art history, and gave art lessons. And, he transformed parts of the large house on Waldhausenstrasse into a Merz environment where he held monthly soirées with Merz performances as often as he could.

Schwitters was totally dedicated to Merz, yet he kept altering his conceptual views of art and moved beyond his Dadaist phase to experiment with cubism, constructivism, Bauhaus designs, and Neue Sachlichkeit. But throughout his experimentation, there was one governing principle: the spontaneous use and appreciation of all art forms and objects to free the imagination from the senseless and banal legislation of life. Complete personal liberty was his utopian ideal—which is not to say that he was a libertarian, for Schwitters had a strong social and political consciousness and realized that society had to be changed if personal liberty and happiness were to thrive, a frequent theme in his fairy tales. But he believed first and foremost in the power of art to respond to arbitrary strictures and structures by

making nonsense out of them so that there might be a re-generation of life.

As he grew older, his total dedication to art was challenged and compelled to undergo a moderate transformation. As an only child, Schwitters had always received special treatment by his parents, and he was extremely self-centered and often unaware of how he used his wife and son to further his artistic career. To be sure, he was devoted to Helma and Ernst and knew that he could not create and live the more "bohemian" life he led in the outside world without their support. But when Germany began to change in the late 1920s, especially with the Great Depression of 1929, and his artwork was not as enthusiastically appreciated as at the beginning of the Weimar Republic, Schwitters became more melancholy and cynical, particularly when he realized that neither Merz nor any kind of art would liberate German society.

When the Nazis gained control of the government in the 1930s, he did not believe they would remain in power very long and thought he could continue producing his artworks. But the Nazis deplored artists like Schwitters. They burned his books ceremoniously in 1934 and dismissed his art as filth. Though he tried to maintain his lifestyle in Hannover and continued to give Merz performances in his home, he gradually realized that he could not go on making public appearances or creating and selling his art without risking his life. Moreover, his son, Ernst, who was a vehement anti-Nazi, had refused to join the Hitler Youth organization and

was in constant danger of being arrested. In 1937, Ernst had to flee Hannover for his life. He went to Norway, where the family had spent several vacations, and Schwitters soon followed. Helma was left to protect the Merz home, their respective parents, and their property in Hannover. That very same year, after Schwitters had left Germany, the Nazis organized an enormous art exhibition notoriously called "Decadent Art" (*Entartete Kunst*), containing some of the greatest works of early twentieth-century expressionist, Dadaist, surrealist, and abstract painters. Some of Schwitters's works were included and, ironically, labeled complete nonsense. In the meantime Helma traveled back and forth to Norway to help her husband and son, who lived under dire conditions. They did not have work permits, and many Norwegians considered them Nazi spies. Helma began making plans to stay with them, and the family thought about emigrating to America, but these plans were dashed by the outbreak of World War II in 1939. In fact, after living only two years in Norway, Schwitters and Ernst were forced to flee to England in 1940 because of the German invasion. Helma remained stuck in Hannover, while father and son almost perished as they made their way from village to village and from fishing boat to fishing boat until they arrived safely in England.

At first Schwitters was interned in different camps in Scotland and England. Then he was transferred to a camp named Hutchinson on the Isle of Man in the Irish Sea. Schwitters, who had been depressed for several years, felt at home with

the other Germans because he could perform skits, give art lessons, and draw portraits. The refugees, many of them gifted artists, intellectuals, and engineers, formed a tiny university. Schwitters was not as despondent as he had been in Norway. When he was released in late 1941, he lived with his son in London for a while and tried to resume his career as a Merz artist. However, despite help from many friends both in England and abroad, the famous art critic Herbert Read among them, he could not earn a living that way and resorted to painting portraits and landscapes. During the war, he managed to stay in touch with Helma and his mother, but he had numerous mood swings. Always dependent on the emotional support of women, he began a long-term relationship in 1942 with a younger woman, Edith Thomas, who was working in a government office at that time. But he missed Helma and worried about her—with good reason. In 1944, the Merz house in Hannover and the other Schwitters properties were destroyed in a bombing raid. Helma developed cancer and died that same year; his mother died in 1945. Poor and sick, Schwitters moved with Edith Thomas to Ambleside in the Lake District, and while earning a living as a landscape painter, he endeavored to transform a barn into a Merz structure and do experimental work with his writing and art on the side. He refused to let his physical ailments, including a brain hemorrhage, stop him. His heart finally gave out in January 1948, and Schwitters died, left out of Germany and left out of the world art scene.

## Merz Fairy Tales

One day the chute in the ceiling [of the Molling factory in Hannover] suddenly opened and a mountain of paper came down. Standing safely at the door with the children, I watched as the avalanche hit Kurt Schwitters, threatening to bury him alive. He stood bent over, defending himself against the onslaught. Then, raising his head, he stood up in the midst of the rubbish, a new Gargantua, twisting and dancing in the whirl of papers. In both arms he held paper, paper, paper. Around his feet lumps, scraps, and buckets of wastepaper swirled. Kurt Schwitters groaned and laughed. Finally he emerged—alive.

—Kate Trauman Steinitz, *Kurt Schwitters: A Portrait from Life*

Left out, but not forgotten, Schwitters re-entered the art world after his death through the dedicated efforts of Edith Thomas, his son, Ernst, and other devoted admirers of his work. It did not happen right away, but Schwitters gradually regained his standing as a great avant-garde artist and enjoyed a more central role in the history of art, instead of being allocated to the margins. Among the papers discovered after his death were numerous fairy tales, grotesques, and stories that had never seen the light of day while he was alive. Many were drafts, and had he not been forced to flee Germany and to labor under poor health and difficult circumstances, he might have polished and honed many of his tales. Despite their roughness and incompleteness, they are incisive if not disturbing reflections of his life and times, and

they incorporate radical notions of the fairy tale as an art form. Schwitters had a biting sense of humor and a strong desire to tear down and recompose traditional forms. His reshaping of the classical fairy-tale structure and his critique of the false illusions of happiness perpetuated by traditional tales coincided with a radical approach taken by many other German writers and artists during the Weimar period.[7] Schwitters's innovations were based on his theory of Merz, which urged artists to decompose what was commonly held to be logical and sensible composition while creating new and unusual works that denied categorization and enabled the reader or viewer to glimpse alternatives to static lifestyles and thinking.

Schwitters was not alone in his endeavors to change the form and function of the fairy tale during the Weimar period.[8] Right after the revolutionary years of 1918 and 1919, communist and socialist writers sought to influence children and adults by publishing highly subversive and original political fairy tales, fables, and stories that experimented with the style and ideology of traditional tales. Several anthologies with political poems, tales, and stories appeared at the onset of the Weimar Republic, such as *Proletarischer Kindergarten* (*Proletarian Kindergarten*, 1921), edited by Ernst Friedrich, and *Pflug und Saat* (*Plow and Sow*, 1923), edited by Arthur Wolf. Most important were the two series of fairy tales produced by the Malik publishing house in Berlin, which had ties to the Communist Party, and the Verlag für proletarische Freidenker in Dresden and Leipzig, which represented a radical

movement against organized religion. Under the direction of Wieland Herzefelde, who employed gifted Dadaist artists such as George Grosz and John Heartfield to illustrate the books, Malik published a series titled "Märchen der Armen" (Fairy Tales of the Poor), which included Hermynia zur Mühlen's *Was Peterchens Freunde erzählen* (*What Little Peter's Friends Tell*, 1920), Eugen Lewin-Dorsch's *Die Dollarmännchen* (*The Little Men's Dollars*, 1923), and Maria Szucisch's *Silavus* (1923). The leading person behind the Verlag für proletarische Freidenker was Arthur Wolf, who was committed to publishing high-quality artistic books that were socialist and critical of religion. He was responsible for several collections of fairy tales: Jozsef Lengyel's *Sternekund und Reinekund* (1923), Maria Szucisch's *Die Träume des Zauberbuchs* (*The Dreams of the Magic Book*, 1923), and Béla Illès's *Rote Märchen* (*Red Fairy Tales*, 1924). Besides these writers, who explicitly wrote politically didactic fairy tales, there were Joachim Ringelnatz, Franz Hessel, Mynona (Salmo Friedlaender), Odön von Horváth, Kurt Tucholsky, Béla Bálazs, Georg Kaiser, and Alfred Döblin, who were less didactic. Others wrote innovative fairy tales and startling parodies, sometimes called grotesques, throughout the 1920s. Their tales were much more complex and avant-garde. Yet, most of these writers, like Schwitters, took political positions somewhere on the Left. They wrote primarily for adults and sought to explode the illusions of the canonical Grimms' fairy tales and to question whether "happiness" was possible in a society that had become so contentious and violent.

Although the Weimar period, 1919–1933, is often thought to be one of the most progressive eras in German history—and it certainly was—it was also one of the most turbulent. When the republic was founded in 1919, it went unrecognized by numerous right-wing groups, and civil war and hyperinflation caused immense problems until the currency reform brought about by the chancellor, Gustav Stressemann, in 1923. Even though there were democratic reforms and remarkable accomplishments in the arts and sciences, conservatives, industrialists, and the army constantly attempted to undermine the social democratic party and the new republic. Assassinations, murders, bloody battles, corrupt courts, and protest marches were common. The conflicts were not only between right-wing and left-wing parties; there was also internal strife among the many different socialist groups and communists. From the very beginning of the Weimar Republic, these differences were apparent, and they were played out in the expressionist, Dadaist, futurist, and surrealist movements. Germans have always had a special affinity and strong predilection for fairy tales, whether for young or old; consequently, the creation of new fairy tales to address and reflect the turbulent times became an even more significant means of voicing opinion.

It is impossible to say whether Schwitters was acquainted with the radical fairy-tale experiments, and yet it seems unlikely he did not read some of them or see some of the illustrations. Lach informs us that Schwitters "had ample opportunity to hear something about old and new fairy tales in

the Hannover Kestner Society from 1920 onward. Lectures on European and Oriental fairy tales were held there many times. On March 5, 1920, Vilma Mönckeberg spoke about 'European and exotic fairy tales.' On December 18, 1922, an evening was dedicated to Oriental fairy tales by Ilse von Kamphoevener. Aside from these lectures, the society organized readings in which modern authors presented their fairy tales and grotesques."[9] They were part of the cultural climate. Every art form was being tested and transformed during the Weimar period. Schwitters associated with some of the illustrators and writers of political fairy tales and spent a good deal of his time in Berlin, where most of the innovations were occurring. In fact, he was very familiar with the efforts to "proletarianize" art, and he had clear opinions about this movement, called the "prolet cult." It has often been said that Schwitters was "apolitical," but this is misleading. If anything, he had well-defined political views and was more clear-sighted about the situation in the Weimar period than many of the so-called political artists.

In 1923, Schwitters signed a pamphlet titled "Mani-fest Proletkunst" (Manifesto Proletarian Art) with the artists Theo van Doesburg, Hans Arp, Tristan Tzara, and Christof Spengemann. Part of it reads:

> Art should awaken the creative forces in a person only with its own means. Its goal is the mature individual, not the proletarian or the bourgeois. Only people with little talent can produce something like proletarian art (that

is, politics in a painted condition) due to their limitations and lack of culture. However, the artist refuses to have anything to do with the special field of social organization.

Art, as we want it, art is neither proletarian nor bourgeois, for it develops forces that are strong enough to influence the entire culture instead of allowing itself to be influenced by social relations.

The proletariat is a condition that must be overcome. The bourgeoisie is a condition that must be overcome. In that the proletarians with their prolet cult imitate the bourgeois cult, they are the ones who support this bespoiled culture of the bourgeoisie without being aware of what they are doing—to the detriment of art and to the detriment of culture. . . . Communism is already a bourgeois affair anyway just as majority socialism is, namely, capitalism in a new form. The bourgeoisie uses the apparatus of communism, which was invented not by the proletariat but by the bourgeoisie, only as a means of renovation for its own rotten culture (Russia). Consequently, the proletariat does not fight for art nor for the future new life, but rather for the bourgeoisie. Every proletarian artwork is nothing but a poster for the bourgeoisie.

On the other hand, what we are preparing is the complete artwork that is above all posters, whether they are made for champagne, Dada, or a communist dictatorship.[10]

In other short essays or notes in his personal papers, Schwitters wrote devastating critiques of nationalism and religion. In this regard, the fairy tales that he created in German and English from 1923 until his death form a composite picture of his philosophical and political views. To be sure, Schwitters had a dark view of politics, and he employed an ironic style to engage with politics in his fairy tales. For instance, in his wry tale "He," written in 1923 and published in 1927 in *Der Sturm*, he recounts how an anonymous young man, simply called He, is recruited by the army and continues to expand and grow into an enormous creature, even though his superiors arrest him and demand that he stop growing. All their ridiculous efforts and plans fail, and the only way the blundering general and the king can prevent his growth is by ordering him to commit suicide, which he does and thus brings about a "happy" end. Schwitters wrote this macabre fairy tale as a grim comment on the inflationary period that was out of control in Germany and also on the stupidity of the commanding officers in the German army.

In another one of his early stories, "Lucky Hans," Schwitters depicts a young man, unemployed and starving, who catches a rabbit to eat. After the rabbit jumps out of its fur and escapes nude into the forest, Hans puts on the fur and earns a lot of money as a circus performer because he is mistaken for a polar bear with a human head. Then there is one banal misunderstanding after another, and Hans demonstrates that he can be just as opportunistic and shrewd as his next competitor. His greatest accomplishment is to out-

wit a rich banker and marry his foolish daughter. Clearly, Schwitters mocks the rise of the poor, typical fairy-tale hero named Hans, whose wealth and happiness at the end of the tale are shallow and vapid. Written during the "golden" days of the Weimar period, when everything was in flux and a new bourgeoisie was on the rise, the tale represents the demise rather than the rise of culture.

In two other pointed political tales, "The Fish and the Ship's Propeller" and "The Two Brothers," both written in 1938, one year after Schwitters was forced into exile in Norway, he critiques conformity and sadism. In "The Fish and the Ship's Propeller," he satirizes the little fish, who at first make fun of a fat fish and then show their fickleness, by quickly changing their attitude after he saves them. Their acclamation of the fat fish as their savior and king is similar to the German people's celebration of Hitler. In "The Two Brothers," Schwitters alludes to the havoc caused by the Nazis, who destroyed the German landscape and humanistic legacy. The brutal brother's treatment of the oak, the land, and his family is clearly a reference to the sadistic and ignorant manner in which the Nazis brought about the destruction of their country and also themselves. Toward the end of his life, Schwitters continued to speak out against conformity, as in "The Flat and the Round Painter," one of the few tales he wrote in English. He could not abide the conventional life and could not tolerate intolerance.

His experiments with fairy tales are a good example of how free association trumped repressive formation and

regulation. "The Scarecrow," which he wrote, designed, and composed with Steinitz and van Doesburg in 1925, is revolutionary in form and content. The "pretentious scarecrow" in his top hat, tux, cane, and lace scarf is not what he seems to be, an elegant, authoritarian figure or a competent scarecrow. There is literally and "letteraly" a barnyard rebellion against his position by the cock, hens, and farm boy so that he is decomposed as a fraud, a figure made up of stolen acquisitions. In the end, his decomposition generates brightness. Of course, this nonsensical tale can be read in many different ways, but the political tendency is clear and lies in the rebellious movement and sophisticated irony of the typography and letters.

All of Schwitters's fairy tales have a political "touch," so to speak, and often his targets of parody are the upper classes that, he contended, were arrogant, materialist, and hypocritical. In a highly amusing tale written during his Norwegian exile in 1938, "He Who Is Mentally Retarded," Schwitters depicts a so-called "idiot," who exposes the hypocrisy of all the fishermen and villagers. His cunning honesty triumphs over the deceit of profiteers. In two other later tales, written during the late 1930s and early 1940s, "The Fairy Tale about Happiness" and "What Is Happiness?" he pokes fun at religion and the naiveté, if not stupidity, of angels to demonstrate that the pursuit of happiness is banal. In the first tale, which he left unfinished, the angel is totally unaware of how social class determines one's spiritual condition; in the second tale, Schwitters alludes to war and fascism and how an

angel, in pursuit of happiness, is oblivious to the suffering of people on earth.

It is fair to say that Schwitters was obsessed by the notion of happiness in his fairy tales, and this obsession was closely connected to his own melancholy disposition and his philosophy of Merz. In 1926, he wrote an important ideological declaration about Merz that can be traced throughout his fairy tales:

### Contemporary Art Is the Future of Art

Merz is a standpoint that everyone can use. It is from this standpoint that all people can consider not only art but all things, that is, the world. For me, Merz has become a world view. I can no longer change my standpoint. My standpoint is Merz. It became this way during a decade of work. I ask the reader here not to be angry with me because I am writing so much about myself, but the development of the thought behind Merz is closely bound up with my personal development and is inseparable from it. If one compares the influence of Merz in greater circles here and there in the world, as, for example, strangely and especially in groups, where the magazine MA seems to be entirely Merz, then, as far as I know, my followers have not contributed anything essentially new or important to the development.

For the standpoint that I call Merz, there are three requirements:

1. Human beings cannot create anything in accordance with the spirit of the almighty divinity. They cannot create nothing out of nothing, rather they can merely create out of definite givens, out of definite material. The act of human creating is only a process of forming that which is given.

2. Perfection [completeness] cannot be attained by human beings.

3. In his work the artist seeks to strive only for that which he can attain. Added to that comes the serious striving to make everything so good, so honest, so open, and so logical as possible. The result from all this is Merz.

Merz is the smile at the grave and seriousness on cheerful occasions.[11]

Much of what people endeavored to make out of their lives seemed senseless to Schwitters, and much of what social and political institutions imposed was senseless. His fairy tales are fascinating variations on this theme: the nonsensical pursuit of happiness in a senseless world. If perfection or completeness was impossible, then it was ridiculous to try to accumulate money, beauty, or even wisdom. This is the clear message in the bitter ironic tale "Happiness," in which a gypsy grants the three wishes of three sisters who wish badly. The third sister is the only one who succeeds in finding a modicum of happiness because she frees herself of human desires. In 1927, Schwitters wrote a brief essay titled

"Glück oder Unglück" about happiness and misfortune, and it begins with the assertion that luck or happiness "occupies many people's minds, but very few know it. I frequently heard someone saying that he didn't have luck. Others always had a good deal of luck, but he didn't. These people don't know luck (happiness), especially not when they assert that they are plagued by misfortune. Because luck and misfortune are the same. Chance is both, and it changes a person through what happens. People initially assume that chance may be luck or misfortune and only realize much later that chance is heading in a different direction. Everyone is aware of the banal fact that luck can change into misfortune, or vice versa, because it is the same thing."[12]

Paradoxically, Schwitters believed that happiness could only be found by not searching for it, as he makes clear in another ironic tale, "The Three Wishes" (1936), in which a man seeks happiness and makes three dumb wishes only to learn that happiness lies within him. In reality, for Schwitters, the notion of happiness was delusion. Only by doing something can one gain a sense of happiness, for autonomous action, especially creating, brings about self-knowledge. Wealth, beauty, love, or marriage cannot produce happiness. It is through words and images that the individual composes and decomposes against a social background that happiness might be detected. In "The Swineherd and the Great, Illustrious Writer," the very first tale Schwitters published in 1925, he announced and demonstrated his Merz philosophy concerned with happiness.

It is only by creating, transforming, and re-creating that both protagonists, the writer and the swineherd—the subject of the writer's masterpiece—become content. Try as he might in his composing and recomposing the swineherd, the great illustrious writer cannot write a masterpiece. He cannot bring his work to perfection, and he cannot satisfy the swineherd because he cannot fulfill traditional expectations. Yet, in the end, the writer attains a sense of serenity because he knows what can or cannot be accomplished.

The emphasis on achieving self-knowledge through incompletion is the overriding motif in all of Schwitters's collages, plays, short stories, and paintings. There is a Sisyphus quality to his thinking and artwork. Schwitters, like Sisyphus, never tired of rolling the rock up the hill only to see the rock tumble back down again just as he was about to reach the top. If the world is nonsensical and banal, and if people are somewhat inane, the artist has no choice but to depict this absurdity and struggle against the social logic that constantly proves to be illogical. The best the artist can hope for is autonomy and self-knowledge through the creative process of reorganizing the ordinary to understand its extraordinary quality and to impress upon viewers and readers how incomplete the world is.

The techniques Schwitters used in his collages are similar to the style and composition of his writing. His collages bring together common elements of daily life that are rearranged to generate new meaning. Forms and figures are reassembled, compelling viewers to rethink the world, that is, to rethink

how the forms and figures have customarily been used or abused. Schwitters collages are acts of salvation that provoke and seek to liberate the viewer from convention and to provide a certain subversive joy. His fairy tales are no different.

Schwitters favored paratactic sentences that appear to be logically causal and yet produce baffling contradictions or silliness. Two good examples are "Fish and Man" and "A King without People," in which the succinct sentences build upon one another often without transition or causality. They are like separate articles or utterances stuck together in such an unconventional and extraordinary way that they produce new connections and form a startling narrative. Patrizia McBride has aptly summarized Schwitters's method: "Schwitters's montage principle entails an assault on the linear unfolding of discourse, which is constantly interrupted by parenthetical inserts that either provide a commentary or contain seemingly unrelated disparate linguistic material. This practice corresponds to Schwitters's characterization of abstract montage as a process aimed at establishing novel, unconventional relations among existing elements. The nonsense produced in this way does not make the impression of chaos, however, but instead unfolds in a highly methodical way, engendering a coherent, parallel universe to sense."[13]

It is debatable whether Schwitters's tales are "parallel universes." They are, in my opinion, more like explosives that shatter closed minds and closed genres. They are closely connected to the "ridiculous" in art that Theodor Adorno discusses in *Aesthetic Theory*:

The divergence of the constructive and the mimetic, which no artwork can resolve and which is virtually the original sin of aesthetic spirit, has its correlative in that element of the ridiculous and clownish that even the most significant works bear and that, unconcealed, is inextricable from their significance. The inadequacy of classicism of any persuasion originates in its repression of this element; a repression that art must mistrust. The progressive spiritualization of art in the name of maturity only accentuates the ridiculous all the more glaringly; the more the artwork's own organization assimilates itself to a logical order by virtue of its inner exactitude, the more obvious the difference between the artwork's logicity and the logicity that governs empirically becomes the parody of the latter; the more reasonable the work becomes in terms of its formal constitution, the more ridiculous it becomes according to the standard of empirical reason. Its ridiculousness is, however, also part of a condemnation of empirical rationality; it accuses the rationality of social praxis of having become an end in itself and as such the irrational and mad reversal of means into ends.[14]

Schwitters's "ridiculous" fairy tales (and montages) carry within their ludic structure a powerful condemnation of the instrumentalization of rationality. They are also a strong and mocking critique of the hierarchy of art and society and the values that are logically proclaimed to be pure and authentic.

There is no legitimacy to a king in a realm where nothing is real or legitimately established. All of Schwitters's tales, collages, and performances are silly. Yet they explode the repressed elements of experience and art. Adorno also asserts that "ridiculousness is the residue of the mimetic in art, the price of its self-enclosure. In his condemnation of this element, the philistine always has an ignominious measure of justification. The ridiculous, as a barbaric residuum of something alien to form, misfires in art if art fails to reflect and shape it."[15] It was to Schwitters's credit that he always played with and shaped the ridiculous and endowed it with a seriousness that questioned the artificiality of high art and the pretensions of the philistines and the bourgeoisie. If art demanded uninhibited play with forms and ideas, and if art demanded a smile, Schwitters was its most dedicated disciple.

Taken as a whole, Schwitters's fairy tales indicate how he grappled with social, artistic, and political problems throughout his mature life. They reflect how he kept his humor in times of great social and personal change. As experiments with the ridiculous, they are earnest endeavors to reform the fairy tale and refocus public attention (and his own) on the disturbing social changes that were having devastating effects on lives. Schwitters never completed his monumental Merz environments in Germany, Norway, and England, and he never perfected his fairy tales. And yet they continue to live on and resonate as traces of remarkable protest artworks created by an artist who refused to yield to the pernicious forces that endanger the creative spirit of humanity. The very

openness and asymmetrical arrangements of his Merz fairy tales that questioned the barbaric and banal arrangements of civilization in his time still challenge us today to question why and how we make our social and political arrangements without thinking about their consequences.

## Notes

1. Kurt Schwitters, *Das literarische Werk*, ed. Friedhelm Lach, vol. 5: *Manifeste und kritische Prosa* (Cologne: DuMont, 1981), 187.
2. My remarks are primarily based on two excellent biographies, Ernst Nündel, *Kurt Schwitters* (Reinbek bei Hamburg: Rowohlt, 1981), and Gwendolen Webster, *Kurz Merz Schwitters: A Biographical Study* (Cardiff: University of Cardiff, 1997), and on the monograph by Friedhelm Lach, *Der Merz Künstler Kurt Schwitters* (Cologne: DuMont, 1971).
3. Schwitters, *Das literarische Werk*, 5:82–83.
4. Lach, *Der Merz Künstler Kurt Schwitters*; 24.
5. This poem was originally published in *Der Sturm* 10.5 (August 1919): 72. It was republished and changed many times during Schwitters's life. The present translation is based on a version Schwitters sent to Christof Spengemann that was published in *Das literarische Werk*, vol. 1: *Prosa 1918–1930* (Cologne: DuMont, 1973), 58–59. The German text is as follows:

An Anna Blume

Oh Du, Geliebte, meiner 27 Sinne, ich liebe Dir!
Du, Deiner, Dich Dir, ich Dir, Du mir, ——wir?
Das gehört beiläufig nicht hierher!

Wer bist Du, ungezähltes Frauenzimmer, Du bist, bist Du?
Die Leute sagen, Du wärest.
Laß sie sagen, sie wissen nicht, wie der Kirchturm steht.

Du trägst den Hut auf Deinen Füßen und wanderst auf die
Hände,
Auf den Händen wanderst Du.

Hallo, Deine roten Kleider, in weiße Falten zersägt,
Rot liebe ich Anna Blume, rot liebe ich Dir.
Du, Deiner, Dich Dir, ich Dir, Du mir, ——wir?
Das gehört beiläufig in die kalte Glut!
Anna Blume, rote Anna Blume, wie sagen die Leute?

*Preisfrage:*
1) Anna Blume hat ein Vogel,
2) Anna Blume ist rot.
3) Welche Farbe hat der Vogel.

Blau ist die Farbe Deines gelben Haares,
Rot ist die Farbe Deines grünen Vogels.
Du schlichtes Mädchen im Alltagskleid,
Du liebes grünes Tier, ich liebe Dir!
Du, Deiner, Dich Dir, ich Dir, Du mir, ——wir!
Das gehört beiläufig in die —Glutenkiste.

Anna Blume, Anna, A — N — N — A!
Ich träufle Deinen Namen.
Dein Name tröpft wie weiches Rindertalg.
Weißt Du es Anna, weißt Du es schon,
Man kann Dich auch von hinten lesen.
Und Du, Du Herrlichste von allen,
Du bist von hinten, wie von vorne:

A — N — N — A.

Rindertalg träufelt STREICHELN über meinen Rücken.

Anna Blume,

Du tropfes Tier,

Ich —— liebe —— Dir!

6. Kate Trauman Steinitz, *Kurt Schwitters: A Portrait from Life* (Berkeley: University of California Press, 1968), 40.

7. See Peter Gay, *Weimar Culture: The Outsider as Insider* (New York: Harper & Row, 1970); Shearer West, *The Visual Arts in Germany, 1890–1937: Utopia and Despair* (New Brunswick, N.J.: Rutgers University Press, 2001); and Eric Weitz, *Weimar Germany: Promise and Tragedy* (Princeton: Princeton University Press, 2007).

8. See my book, *Fairy Tales and Fables from Weimar Days* (Hanover, N.H.: University Press of New England, 1989.

9. Lach, *Der Merz Künstler Kurt Schwitters*, 140.

10. Schwitters, *Das literarische Werk*, 5:144.

11. *Ibid.*, 5:247–48.

12. *Ibid.*, 5:293.

13. Patrizia McBride, "The Game of Meaning: Collage, Montage, and Parody in Kurt Schwitters's Merz," *Modernism/Modernity* 14.2 (April 2007): 255.

14. Theodor Adorno, *Aesthetic Theory*, trans. and ed. Robert Hullot-Kentor (Minneapolis: University of Minnesota Press, 1997), 118–19.

15. *Ibid.*, 119.

**Tales Written in German** ■

bim–bam

## 1 The Swineherd and the Great, Illustrious Writer

A swineherd was tending his pigs and playing his flute at the same time: "Tweet, tweet, tweet, tweet, tweet, tweet, tweet."

A great, illustrious writer came by and asked him whether he was indeed happy. The swineherd opened his blue eyes and looked at him as though he were gazing deep into the sea. Then he spoke: "I am, indeed, serene and also content, but I'm not happy. Oh, if only I were a fairy-tale prince! Just think of how many swineherds are children of royalty! How many!"

And he pointed to his bible in which he had read about them, and which he used as a pillow. Well, the illustrious writer was so moved by the swineherd that he took him and set him *bim bam!* right into the middle of his masterwork, his very best fairy tale. And there he sat, the swineherd, with

his beautiful blue eyes, and he was a real prince, the genuine son of a king, and he tended his father's pigs and played his flute at the same time: "Tweet, tweet, tweet, tweet, tweet, tweet, tweet."

And the illustrious writer asked him whether he was now really happy. The swineherd prince opened his beautiful blue eyes and looked at him as though he were gazing deep into the sea and said: "I am, indeed, serene and also content, but I'm not happy. Oh, if only I had a lovely little woman who could tend the pigs as nicely as I do. Just think of how many swineherds have a tender, lovely little woman!"

The illustrious writer was glad that he had asked the swineherd ahead of time, for he still hadn't finished the fairy tale, his masterwork. And *bim bam!* he retrieved a tender, lovely little woman from somewhere in his imagination, a maiden with long blonde pigtails and with blue eyes and a little red skirt. A maiden who could tend the pigs just as nicely as the swineherd prince. And it did not take long before our swineherd prince fell in love with her and couldn't take his eyes off her. It was as if he gazed at the sun, for wherever he looked, he saw her slender figure, the red skirt, and the long blonde pigtails.

So the illustrious writer asked him whether he was now indeed happy. However, the swineherd prince began by saying: "Oh, my great, illustrious writer, I was serene and also content, even though I wasn't happy. However, now I am no longer serene and don't have any peace of mind. As for being happy—I'm certainly not happy!"

And so the illustrious writer asked him whether he would prefer that he removed the maiden with the red skirt and the long blonde pigtails from his masterwork, the fairy tale, in which the swineherd was now living. However, our swineherd prince opened his beautiful blue eyes and gazed at the great, illustrious writer, and his eyes were as wet as a sea whipped by a whirlwind, and he said, "I'm no longer serene and also no longer content. However, happiness can easily come from such a young maiden. So, leave me be! I have time. I can wait. If I can ever become happy, my happiness will depend just on my being with this maiden."

And our illustrious writer promised not to remove the little maiden from his masterwork without the swineherd's approval.

And now the sunset became so red, and the sun glistened so brightly at night, and the morning was so full of dew and freshness, and the fog was so wistful and beautiful like a bridal veil, and the first kiss was like a mother's blessing and was so sweet that there is not enough sugar to describe it. And now that they had learned how to do it, they began kissing each other every two or three minutes, and they continued kissing each other all the time except when they had to eat and do some other necessary things.

Once again the great, illustrious writer asked our swineherd prince whether he was indeed really happy. In response the swineherd opened his beautiful blue eyes and said: "Happy?—I was happy for a moment at the first kiss. Now it's over, and my serenity is gone, and I no longer have any peace

of mind. Everything is gone, and I must somehow regain my happiness. I must make that lovely maiden my wife. After all, most of the swineherds are married!"

Then the illustrious writer became very serious, for he couldn't give the simple peasant maiden with the little red skirt and the long blonde pigtails to the son of a king, and he said to the swineherd prince that he had to realize that he was not a lowly and simple swineherd, but the son of a king, and it was not appropriate for the son of a king to marry a simple peasant maiden. What would the king, his father, who graced this masterful and beautiful fairy tale with his elegant presence, say? What would the old dignified man say? Then the swineherd gazed at him with his beautiful blue eyes and said: "What's the purpose of my being the son of a king? I had thought I could marry whomever I wanted, and now I'm not even supposed to marry this lovely, beautiful, and delightful maiden, because she is too lowly for me. But I don't want anyone else, even if she might be from a better class. I don't like those scarecrows, who smell like violets and flap like flags. Let me remain a simple swineherd. I've had it with being the son of a king."

Then the illustrious writer became very sad and said that he had placed the poor swineherd into his masterwork as a friendly gesture and had raised him *bim bam!* to the rank of prince, and he had given him a maiden as a gift for his amusement, and now this was the way the swineherd thanked him, by wanting to destroy this beautiful fairy tale, this masterwork. "Stubborn mule!" he yelled at the swineherd. "How can I let the king, your honorable father, become a beggar at

the end of my masterwork and reduce him to the father of a mere swineherd? How can I do something like this? Isn't there composition and tact and rhythm in my masterwork, and shouldn't I maintain my work just as it is? How would I come off as a great, illustrious writer if I were to reduce the good old king, your honorable father, to a beggar after I spent two hundred pages allowing him to be king and then said that everything I had written before had been an illusion, deception, and mere mess? Just because it would please you? Do you think that I'm your servant? I'd ruin my entire career all because of your stupid pubescent love! Let me tell you something: you can't marry that woman. She's not suitable for someone of your rank. You can love her, but you must marry someone else who is beautiful, smells like violets, and wears glorious floating and rippling gowns."

Our swineherd withdrew so deeply into himself and became so sad that he had to weep with his beautiful blue eyes and said: "Well then, remove me from your masterwork, my great, illustrious writer. I'm only disturbing it. I'm not fit to be the son of a king. Stick me into a minor work, but let me remain a swineherd."

"What good will all that do?" the illustrious writer responded. "If you appear in a minor work, you still wouldn't be happy in it. I've learned this from all the bad experiences that I've had with you because you've been so ungrateful. You'd only destroy that work as well. So, I won't do it!"

"Then set me free," said the swineherd. "Let me go off in peace and send me back to my meadow where I can tend the

pigs owned by my master as I was doing before, and let me take the maiden with the little red skirt with me."

"I can't do this," said the illustrious writer. "I can certainly give you back your life and let you live in peace. However, the maiden is nothing but my imagination. I can't give her to you. She isn't even alive. What would you do with her? She's only a piece of paper, printed on both sides, with words that you can't even read."

"Then set me free," said the swineherd. "I must return to my meadow."

And *bim bam!* our great, illustrious writer removed him from his masterwork and returned him to the meadow and the exact place where he had found him. And now he asked him whether he had finally become happy. Then the swineherd said: "My illustrious writer, I've become serene and also content. Through you I've seen happiness. However, I don't want it. There's happiness, but it comes at the cost of my serenity and peace of mind. What should I do with such happiness? Oh, don't ask me whether I am now happy. I don't want to be happy. Let me alone with my serenity. Let me alone with my peace of mind. Why don't you live in the happiness of your imagination, my great, illustrious writer?"

"Swineherd," said the writer, "you are wiser than I am. Why should a man run after happiness? There's no happiness that lasts longer than a moment. Give me some of your serenity, something from your peace of mind, and I won't want to be happy anymore."

So the swineherd took the illustrious writer by his hand and gazed at him with his blue eyes as though he were looking deep into a sea and said: "Come, sit down beside me. We'll tend the pigs, you and me. We'll eat, drink, sleep, lie in the sun, and our entire concern will be the welfare of the pigs. That's not happiness, but it is serenity and peace of mind." ■

...now Hans made for
an imposing appearance.

## 2  Lucky Hans

One morning Hans was quite unhappy because he had neither job nor money, and his only suit was tattered. Moreover, it was cold, and he was hungry. However, he was too good a person to steal, and so he froze and starved.

When Hans went walking through a forest, he came upon a willow tree standing in a meadow. It was twenty times as large as he was, and it was hollow, and above him a gooseberry bush was growing on the tree like mistletoe. Hans wanted to climb up to the gooseberry bush, but the willow tree was so hollow inside that he didn't dare try. So he threw his entire weight against the tree trunk and gave it one huge push so that the willow tree fell down and crashed like the slamming of a door. The most glorious gooseberries were hanging on the bush, and Hans ate until he was full and cheerful. But he was still freezing.

All at once a little rabbit ran across his path and came so close to him that he only had to stretch out his arm to catch it. As he was examining the little animal closer and thinking about how he should prepare it for a meal, the rabbit jumped out of its fur and ran naked back into the woods. Hans had its fur in his hands and called out to the little rabbit, "You poor animal, you're certainly going to freeze!"

But then he tried to see whether he himself could put on the rabbit's fur. Indeed, it fit him perfectly and even covered his boots and hands and reached his head. Now Hans made for an imposing appearance in his gigantic fur, and this was

the way he looked when he entered the city. People crowded around him, for they believed they were witnessing a wandering polar bear with a human head. At that very moment there was a circus in town, and Hans was recruited as the new human bear and earned loads of money. But after all the people had seen the miraculous human, and after they realized that he couldn't even growl, he was fired from the job. So, he sat on the road once again, but this time, mind you, he had a sack full of money that he had honestly earned.

Now a rich man approached him and asked him how much he wanted for the bearskin because he had a great desire to buy it. Well, Hans replied that he had already earned a sack full of money with it. Nevertheless, he would be willing to sell the fur because it turned out to be a bad business to be stared at by dumb crowds that regarded him as some kind of miraculous animal. However, he wanted one whole gold bar for it. The rich man said that he had plenty of gold bars, and the price made no difference to him. Furthermore, Hans said that he was wearing a very simple and tattered suit beneath the fur, and he couldn't run about with such a suit, given his present wealth. So, in addition to the price for the fur, he demanded a perfectly new suit tailored according to the latest American fashion, a pair of patent leather boots, and an elegant cardigan. The rich man agreed to all of this. Finally, Hans demanded a small jacket for the naked little rabbit from whom he had taken the fur. The rich man was astonished that the bearskin was just supposed to be a rabbit's fur and thought that Hans was a little strange. Nevertheless,

he agreed to give him the jacket in exchange for the naked little rabbit's fur. This time, to be sure, it was going to be tailored according to French fashion.

"Now, is that everything?" he asked.

Then Hans requested that the exchange be performed in the presence of a notary public, who was to note down the entire protocol in advance. Well, as the notary public was drafting the protocol, he repeatedly tried to write down "polar bearskin." But Hans was smart and did not allow this. He repeatedly corrected "polar bearskin" to read "rabbit fur." The notary public had to laugh, and now he, too, considered Hans strange, but he wrote down "rabbit fur." After Hans and the rich man signed the protocol, Hans took off the rabbit fur and stood there in a suit that had more holes than stitches. However, the tailor presented him immediately with the new American suit, the leather boots, and the cardigan so that Hans soon appeared as chic as the rich man himself, except that he was unshaven and dirty, and his hair had not been cut for some years now. But who can think of everything right away? The rich man held the fur in his hands and was puzzled as to why it was so small. But he had been convinced in the presence of the notary public himself that it was the correct fur and consequently wanted to try it on. Yet he found that it wasn't even large enough for him to use as a glove. Now his mood turned sour because he had spent so much money for it. So he split the gold bar down the middle and offered half of it to Hans. But Hans insisted on his legal rights, and the notary public had to admit that he was correct. Consequently,

Hans was awarded one whole gold bar and, in addition, he received the tiny jacket for the poor little rabbit.

As soon as this was done, Hans ran immediately into the woods with the tiny jacket and searched for the little rabbit. But the rabbit had crawled away and had hidden somewhere because the poor thing had been freezing and was thus not to be found. Hans shouted louder and louder, and when he arrived at the fallen willow tree again, the little rabbit truly appeared and was as naked as a newborn baby. So Hans put the jacket on it, and the rabbit looked so cute that Hans did not want to part with it any more and asked the tiny thing to accompany him as his pet. The naked little rabbit was content, nodded with its head, and let Hans carry it in his arms into the city, where he went directly to a barber for a shave, haircut, and shampoo. You won't believe me when I tell you just how much dirt spilled out onto the floor! Afterward Hans smelled nice and clean from cologne and was now a gentleman from head to toe, for he had a perfect part in his hair. Well, while he was still there, the barber said to him, "Your little child is very nicely behaved."

"That's not a child," Hans replied. "It's a little rabbit."

"Well, it's very tame," the barber offered his opinion.

"Wrong. In fact, it's a wild little rabbit."

And all that was so amusing that the barber and all his young assistants stood at the door when Hans left, and they looked at him as he walked away and thought what a strange man he was with the naked little rabbit.

Now Hans went to the home of the rich man who had bought the fur in order to offer him the little rabbit as well. However, the man wasn't at home, but his daughter, Miss Elli, was. So Hans asked politely for the privilege of waiting for the rich man, and he was led with his little rabbit into the parlor. Oh, what beautiful furniture there was! Biedermeier and rococo, and there were numerous chiseled corners and also many Oriental rugs and brown clay statues of gypsies on lathed pillars, a porcelain oven, cast iron deer and moose, a porcelain terrier sitting on a tiger skin, a stuffed badger that already had moth holes, and all kinds of other beautiful things. Just then a cuckoo clock struck twelve and played a hymn. Hans looked around and around and then around one more time and said, "Now it's going to strike thirteen." But the young lady thought that he must have miscounted. Hans made himself comfortable in an easy chair, smoked one cigarette after the other, and was soon involved in a discussion with Miss Elli. Smoking suited him extremely well except that he still had dark blue rims on his fingernails because he had not yet had a manicure. Elli was puzzled by this remarkable mixture of the gentleman in a suit with the appropriate face and hair and the rugged man of the people in motion with hands that were very thick and red. But she found the little animal simply sweet and promised that she would support Hans when he spoke to her father.

Well, the father had a good day at the stock market, and when he heard that a gentleman with a rosy thing was in the

parlor, he entered in the best of moods. But imagine his disappointment when he recognized Hans.

"What!" he sputtered. "Do you want to ruin me? Perhaps you want to palm off another rabbit fur on me that's not worth one red cent? How many gold bars do you want this time?"

"Two," Hans replied very calmly.

Then the rich man became furious and said, "The door is over there, sir!"

However, Elli put in some friendly words for her gentleman and said that Hans possessed a delightful rosy thing dressed in a charming little jacket. She'd love to have such a tiny rosy thing from him. The father was very irritated, but he didn't like to deny his daughter's wishes, and so he asked Hans what the rosy thing cost. When Hans realized now that the man was interested in the affair, he said, "This thing, well, it costs three gold bars."

The old man was not used to bargaining, and so he paid three gold bars without a blink of the eye. In turn, Hans said that he was giving away the little rabbit so cheaply because it was the only way that the rabbit could get back its fur. But then Elli was very disappointed and asked, "Is that really just a little rabbit?"

"If I've said it, then that's the way it is. Just fetch the fur, and the little rabbit will slip into it right away."

So, someone fetched the precious fur, and the rosy little rabbit that was now worth three times its value took off the

little jacket and slipped into the fur. And now it could not be told apart from a very ordinary little rabbit. What a bunny!

But the rich old man felt that he had been swindled somewhat and wanted to throw Hans out of the house that very moment, causing Elli to weep such heartbreaking tears that her father couldn't do it. Instead, he began to bargain with Hans about the dowry, for Elli insisted on marrying the chic gentleman. Knowing this, Hans demanded two hundred gold bars as dowry, and that was quite a lot. He also demanded to become a partner and attorney in the father's bank. And everything happened just as he wanted. Hans was hired by the bank and climbed upward until he became the general director. Indeed, he had a most extraordinary ability to turn the worst documents and stocks that were completely worthless into solid money. Therefore, the bank flourished under his direction. And only three weeks later, whoever encountered Hans and saw his manicured hands could not believe that he only recently had the heavy dark hands of a worker. Indeed, he had become a real gentleman, the number one dignified celebrity of the city, and Elli loved him tenderly.

So Hans gained wealth, happiness, and love. The little rabbit became their domestic pet, and the gooseberry bush was planted on the large circular flower bed in the garden, richly fertilized and cultivated with care so that it grew to the height of a fully grown oak tree.

And so ends the fairy tale of lucky Hans. ■

Then the three had
different dreams

## 3 Happiness

Once upon a time there were three sisters who looked alike. They weren't beautiful. They weren't rich. They weren't smart. But they lived simply, quietly, and contentedly. Then the three had different dreams. The first one dreamed that great happiness would be bestowed upon them. The second dreamed that they would be able to find happiness themselves with the help of a gypsy. The third dreamed that they would find happiness only if they made the right wish. And then, soon after their dreams, a gypsy happened to arrive. She had a bundle of presents under her arm and gave each sister a choice. The first sister wished to be beautiful; the second, to be rich; the third, to be smart. Then the gypsy said, "Your wishes are bad," and she disappeared.

The first sister became so beautiful that the sun didn't dare to shine because the young woman was more beautiful than the precious sun itself. Whenever she went out, she was immediately followed by a hundred men because she was so beautiful. And if another woman encountered her, that woman would curse her and turn away because she was so beautiful. The married men loved her more than their own wives because she was so beautiful, and their wives wanted to scratch out her eyes because they were so beautiful. The men fought duels in her behalf and shot each other because she was so beautiful. And she only stood there and laughed; she could do nothing else but laugh because she was so beautiful. But the more beautiful she became, the sicker she became

since death had no fear of beauty. And when she was about to die, all of the men cried with broken hearts because she was so beautiful, and all of the women rejoiced because she had to die. And the same old gypsy appeared before her death-bed and said, "You should have wished for health!" Then the beautiful woman died.

The second sister became extremely rich. She lived outside the city in a villa in a gigantic park with lakes and artificial mountains. She had her own airport, numerous cars and sofas, and servants and friends, just as much as she wanted. That was how rich she was. And her ships sailed in the waters of India and Palestine and Australia and Greenland. That was how rich she was. And she spread butter lavishly on cheese and never ate bread or potatoes. That was how rich she was. And she had a husband who admittedly did not love her, but he did anything she wanted. That was how rich she was. And she had her own language and her own kind of phonetic script invented for her correspondence. That was how rich she was. And whenever she went to the theater in the evening, she bought out the entire house and sat completely alone in the former royal loge with her Pomeranian dogs, pearls, and diamonds. That was how rich she was. Once when she went walking and saw a child on the street with some buttered bread, she became vexed because the buttered bread did not belong to her as well. That was how rich she was. Then she met the gypsy again, who said to her, "Your wish was wrong, for you are not content. You should have wished for contentment. Then you could easily do without all of your riches."

The third sister had become smart. She was so smart that she knew the bible in its original version by heart and could recite it backward and forward and could produce the cubic roots of twenty-digit numbers from her head. She was so smart that she knew that the men could not stand her because of her brains, and because she could think much faster and much better than any man. That was how smart she was. Eternity was for her only a question of space and time, which could not be acquired with money, and she was so smart that she knew that being smart was entirely insignificant to feeling happy. Yes, she even knew that the opposite was true, that dumb people feel much happier than smart people. And she herself had also felt much better in the past than she did right at that moment. She knew just about everything. For instance, she knew that something would happen again in the Balkans, and she knew that peace conferences would only lead to the next war, and that pacifists were nothing more than strategic pawns for the Bolsheviks. She even knew where the gypsy lived, and she went there. She was so smart that she returned her gift to her. Then the gypsy said, "You also made the wrong choice, but what would you like now?"

"Wisdom," the third sister replied.

Then the gypsy said, "I don't have to give that to you because you have it already."

So the third sister succeeded in becoming happy because she managed to free herself of human desires, and she knew that she had been happy before the gypsy had arrived and given her the fatal gift of smartness. ■

tick-tock

## 4   The Little Clock Spirit and the Lovers

Once upon a time there was a large clock that lived far from the city, very far. It didn't live on the wall in a house, nor did it live on a high church tower or in a large train station. It lived far from the city, very far, where there was a garden, bug-ridden, especially in May, and that's where it lived. That's where the large clock lived and went "tick tock" and "tick tock."

A pair of lovers, a young man and woman, came there, and they didn't hear the ticking: "tick tock" and "tick tock." They loved each other very much in May when the lilacs were blooming, and a thousand smells perfumed the air. The young man grabbed the woman around her hips. Yes, yes, it was May! Alas, the month passes by quickly. And the large clock just kept ticktocking. All alone. But there was a little spirit living in it as in a theatrical revue.

Eventually, the two lovers heard the ticktocking of the clock. And it continued to go: "Tick tock, tick tock." And the large, large clock continued to ticktock in the bug-ridden

garden in the beautiful month of May when all the flowers were blooming.

"Oh," said the young woman, "what's the meaning of the ticktocking in this bug-ridden garden in the beautiful month of May when all the flowers are blooming? Why is the clock ticking and tocking? I don't want to know how much time has passed!"

The little spirit in the clock sensed that something bad was about to happen. And it continued to announce: "Tick tock, tick tock" and "ticktock" and "ticktock." Just as it had learned. And just as a real clock spirit was supposed to do.

All at once the young man took his long cane and put the little clock spirit to flight. So the pendulum stood still. Just like a mill when the wind does not blow. And our young woman gave the young man a long kiss. ∎

## 5   The Proud Young Woman

Once upon a time there was a beautiful young woman, and she was very proud. And she discovered the weak spots in men that were not as noticeable as wise Mother Nature had thought they would be. And a man came to court her who was, mind you, not handsome, smart, or noble, but he was filthy rich. Nothing held him back, and he could do anything he wanted. But the proud young woman rejected him with words as sharp as thistles and told him that he wasn't rich enough. So the rich man uttered a curse and left. As he departed, he encountered the second suitor already on his way to see her. He was, mind you, not rich, handsome, or smart, but noble. His forbears came from the oldest family of the city. But the proud young woman also turned him away by rejecting him with words as plump as prunes and told him that he wasn't noble enough. So he, too, uttered a curse and left. And as he departed, he encountered the third suitor already on his way to see her. He was, mind you, not rich or noble, and also not smart, but handsome. He was the idol of all the teenagers. But the proud young woman rejected him as well with words as sharp as thorns and told him that he wasn't handsome enough. So the handsome man uttered a curse and left. As he departed, he encountered the fourth suitor already on his way to see her. He was, mind you, not rich, noble, or handsome, but smart. He was a doctor. Moreover, he was a professor. He told her that he had come to woo her for a good friend. But the proud young woman said, "No,"

and left him standing. The smart man, however, did not utter a curse. Instead, after three years, he returned, and the proud young woman asked him whom he was representing this time. When he said that he was courting her for himself, she rejected him with words as bitter as sour apples and told him that he had had better prospects before, but now he was not smart enough. The smart man gave back her sour words and said that the next time he would have much better prospects. However, the young woman just looked into her mirror.

After three years had passed, the young woman had become prouder than before. Mind you, she wasn't richer, nobler, or smarter, and not even more beautiful, for she began to show her age and pretended to be very dumb. And the smart man returned and acted as though he didn't want to court her, not for himself or for anyone else. The young woman didn't know what he wanted.

Indeed, there had never been a man who had come to her and hadn't wanted to woo her. And he replied expressly to her frank question whether he perhaps had come to woo her that he had no desire whatsoever to marry and was not fit for marriage. The young woman was not smart enough to see the cunning in his remark. Rather, she felt that her pride had been insulted and that the man was not courting her, and therefore she was friendly to him. Eventually, she led him to the point that he could not be anything other than a polite man who had to court her. But the smart man was smarter and didn't do it, for it had become clear to him that the charms of this young woman were fading fast. So

...but he was filthy rich

he went home. And when the young woman looked into her mirror, she saw she was old and was somewhat horrified. It was as if suddenly her pride had broken. Now she wanted to marry—and that was certain. But since nobody came to visit her anymore, she invited the gentlemen to come to her. First she invited the handsome man she had rejected with words of thistles. He returned her words of thistles, and they hurt. Then she invited the noble gentleman to whom she had uttered words like prunes, and he returned those words that now felt like pits. He was very hard. Then she summoned the rich man to whom she had spoken words like thorns, and when he saw her, he became terrified and returned her sharp words. Now the woman invited one suitor after the other, and each one returned a gift that she had given him. She became so ill from all the pain that her pride died. She went out on the street and searched for a man, but she found nobody, and the men amused themselves with her. Then she became very sick and finally died when evening came. And not one man wept for her. ■

## 6 An Old Fairy Tale

This is a gruesome fairy tale, but it also happened very long ago. And how often is it that someone is punished for a deed that wasn't evil but well-intended?

Once there was a man, and his name was Frederick Peace because he was entirely peaceful. He was so gentle that he never harmed a soul, not even a flea. And one day, as he was wandering about the forest without thinking of anything evil, a small bird came hopping toward him, and it had a lame wing. It looked so miserable that Frederick felt sorry for the bird and picked it up in his hand. All at once the bird cried out with a clear human voice, said his name, and told him that she was actually a charming young maiden and had been transformed into a bird by a sorceress. Frederick was totally horrified when he heard this and looked around him to make sure that he wasn't dreaming. But there were sunspots; it was a bright day. Soon four other little birds arrived and were just like the first one, only more beautiful and healthy. They sang and flew around Frederick, and the first bird said that they were her four companions who had also been transformed by the sorceress. Frederick felt deeply sorry for them, and he asked whether there was anything he could do to free the birds from their enchantment.

So the lame bird said, yes, he could help them if he did what she told him. And Frederick asked what he had to do.

"We five birds can be saved," said the bird, "when you twist off my head."

twist off my head

Frederick got chills because he had never harmed a flea in his entire life. Then the bird continued, "After you have twisted off my head, a large atrocious man will lie before you with cuts on his throat and arms. That will be me, and my four companions will become maidens again and will stand around you and will be shrieking. You're not to pay any attention to their shrieks. Instead, you must cut off my head completely from my body. Then, all at once, I shall stand before you as a charming virgin, and you will certainly receive my gratitude. If you don't have the courage to cut off the large atrocious man's head completely from his body, then I shall have to die, and you, too, will have to die."

Frederick hesitated because the whole thing sent shivers up his spine. But the bird had already laid its head in Frederick's hand, and he finally overcame his inhibitions and twisted off the bird's head. And everything happened just as the bird said it would. A large atrocious man in the process of dying from wounds on his throat and arms lay right in front of Frederick. The four maidens stood around him, shrieking and calling for help, and Frederick himself had a long, bloody knife in his right hand just like a real murderer. Then Frederick remembered that he had to cut off the man's head completely from his body. However, he hesitated because he had never harmed even a flea in his entire life. The atrocious man was already becoming weaker and weaker and would soon have to die, and Frederick didn't have the courage to cut off his head completely from his body. Finally, just when he summoned the courage and began bravely to cut off the

head, the large atrocious man died. All at once two men stood behind Frederick. They had come running because of the shrieks of the four maidens, and they grabbed and bound Frederick, whom they regarded as a murderer, even though he had never harmed a flea in his entire life. Then he told them how everything had occurred, and the four maidens were no longer there because they had been transformed once again into four silvery white birds. The two men, however, couldn't put all the pieces of his story together. Indeed, who could possibly have connected them without having experienced such things? No matter how much Frederick told them and denied any wrongdoing, no matter how much he swore and pleaded, the two men had no choice but to take him to jail, where he was put in chains. Nevertheless, Frederick was in good spirits because he knew his case was good and just, and he believed that the wise judge would judge wisely. Yet, even though he had the best intentions, the judge couldn't clear up the case. The four maidens could no longer be found, and the court didn't believe that they had been transformed into four silvery white little birds. When the four birds circled the courtroom and continually knocked against the windows, everyone regarded them as Frederick's pet birds. In addition, the identity of the dead person could not be cleared up. The passport that the atrocious man had been carrying could not be verified, and he had not been reported missing anywhere in the world. Nobody fit his description. Instead, it was reported that, many years ago, four maidens and a virgin had suddenly disappeared in those woods without leaving a trace

behind them, and a story had been spread in those parts that an evil sorceress had transformed them into five birds. This story had become legendary and so well known in the region that everyone surmised Frederick had known about it and used it as his excuse to save himself. And so the court sentenced Frederick to death by hanging.

Before the execution, the court tried to make Frederick confess. But the accused man stubbornly refused to do so. The large crowd mocked the four little silvery white birds that fluttered over the gallows and called them flying maidens. Because of this, the entire execution became very comical and interesting, for the people cracked some neat jokes about the four birdlike maidens. The funniest thing, however, was that the accused did not pay attention to the crowd at all. Rather, he just kept looking at the birdlike maidens. He flirted with them while he was still on the gallows, and the people considered him to be a terrible criminal. Then he was hanged, and when Frederick died, the four little birds fell from the sky.

Now the people had a sign, and they knew that Frederick had been unjustly punished. The wise judge had to flee because the people were so enraged, and from then on, no judge dared to sentence anyone because nobody could make a judgment anymore according to his innate intelligence. ∎

Typographic transcription by Barrie Tullett

---

# THE SCARECROW

## M E R Z 14/15

TYPOGRAPHIC DESIGN BY
KURT SCHWITTERS  KATE STEINITZ  TH. VAN DOESBURG

---

# THE SCARECROW X

Once  upon a time there was

a scarecrow that had a top hat

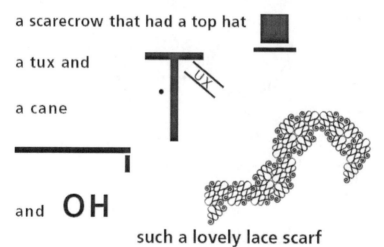

a tux and

a cane

and  **OH**

such a lovely lace scarf

# THEN came Monsieur

le coq

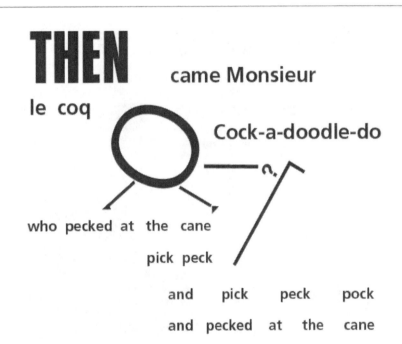

Cock-a-doodle-do

who pecked at the cane

pick peck

and pick peck pock

and pecked at the cane

# A N D

**he didn't have a cane**

 **and O H**

such a lovely

LACE

SCARF

**THEN** the hen arrived

P Phooey

A**N**
**D** Monsieur L E CO Q SA ID to the Hat

the tux and the cane and the **O H** such a
lovely **LA** CE **SCA** RF Phooey old man you're
a measly scarecrow Pick Peck and pick peck pock

**THEN** **ALL** the hens arrived and
showed no fear of the cane and they pecked

P I C K    A N D    P E C K

AND    pick    peck    pock

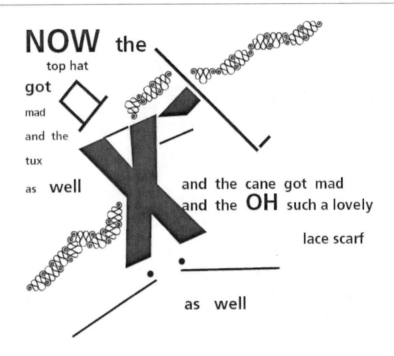

**NOW** the

top hat

got

mad

and the

tux

as well · · · · and the cane got mad

and the **OH** such a lovely

lace scarf

as well

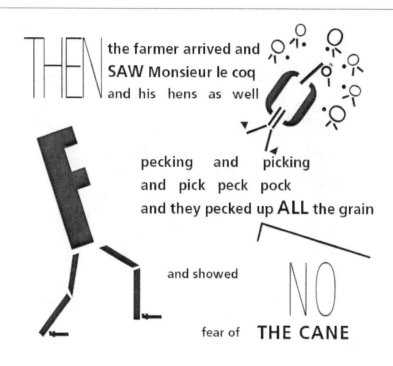

**THEN** the farmer arrived and **SAW** Monsieur le coq and his hens as well

pecking and picking and pick peck pock and they pecked up **ALL** the grain

and showed **NO**

fear of **THE CANE**

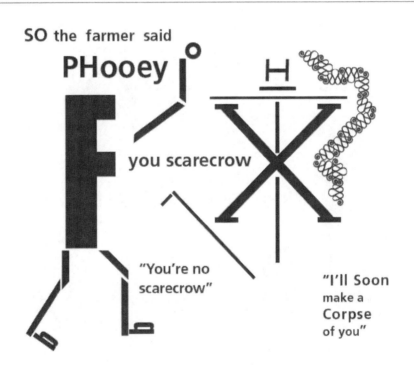

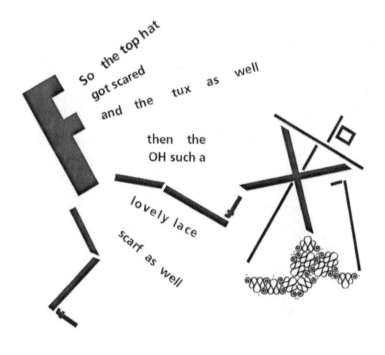

So the top hat
got scared
and the tux as well

then the
OH such a

lovely lace

scarf as well

But
Monsieur le coq
and his
hens
kept
pecking and picking
pick  peck  pock

p <sup>e</sup> c <sub>k</sub>

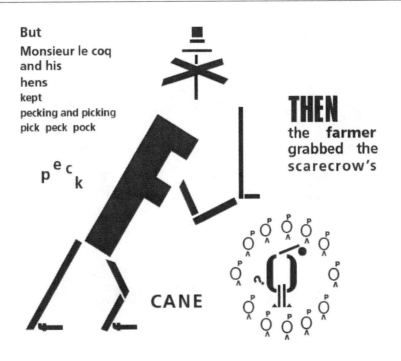

**THEN**
the  **farmer**
grabbed  the
scarecrow's

CANE

and suddenly
　　　it became
　　　　　so dismally
　　　　　　　dark

Nobody saw and nobody pecked
pick peck and pock and pock and peck . . .

# NOW the top hat
was glad and the tux
as well and the OH so
lovely lace scarf as well

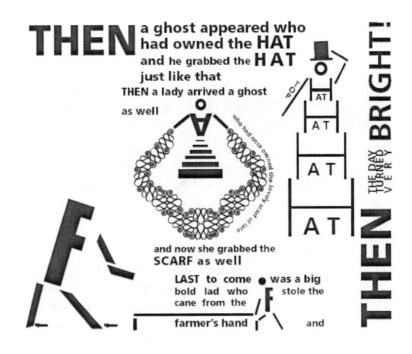

**THEN** a ghost appeared who had owned the **HAT** and he grabbed the **HAT** just like that

THEN a lady arrived a ghost as well

who had once owned the lovely scarf of lace

and now she grabbed the **SCARF** as well

**LAST to come** was a big bold lad who stole the cane from the farmer's hand and

**THEN BRIGHT!**

THEN THE DAY TURNED VERY

## 8  He

In the meantime He had become a fully grown man. So they gathered together, and after consulting with each other, they agreed to accept Him into civil society. He was to help regenerate our degenerated culture. But things happened otherwise. First they had Him confirmed, and when He stepped up to the altar, they all noticed that his pants were too small for Him. He must have already grown somewhat more in the meantime, for his new sleeves seemed also to have shrunk.

"My boy," said his mother, "what's going to happen next? You'll soon be much too much for all of us."

Indeed, He was already larger than anyone else, and now He himself noticed it. In general He didn't talk much and usually said only, "Good morning, good evening, good night," depending on the time of day. Or, "I'm hungry. Give me something to eat. Lay me down in bed," depending on his needs. Nor did He ask many questions, and so He forgot to ask whether He should now stop growing, and therefore He continued to grow. He was already even taller than any of the soldiers, and so they gathered together again, consulted with one another, and demanded that He become a soldier. That could have almost become a disaster for all of humanity. But He went and did as He was ordered. He joined a company and was the tallest soldier.

One day the lieutenant noticed that the man who marched on the flank was at least one and a half times taller than the soldier next to Him. So now the officers consulted with one

I'm hungry...

another to decide what they should do because if the general were to notice this, the major would be made to look ridiculous. Therefore, they had to think up some way to make the soldier on the flank shorter. So they had a helmet made that weighed a hundred pounds, and He had to wear it. They measured Him every morning and evening, but when He shrunk a bit during the day, He grew even more during the night. Soon He was twice as tall as the soldier next to Him. That looked horrible. The lieutenant was scared stiff for good reason. If the general were to notice this, and if the major were made to look ridiculous because of this, the lieutenant would be dismissed from the army. . . .

All this did not seem to disturb the tall man even when it was rumored that his excellency, the general, would inspect the troops in ten minutes. The lieutenant became sickly anxious, because the soldier, whose position was on the flank, stood there tall as a tree. The general, who was the supreme commander, had already arrived, and the tall man stood there, because they had not been able to remove Him fast enough. The supreme commander was impressed by the high spirits of the troops and didn't notice the man, who stood as tall as a tree, even once.

Whether the supreme commander really hadn't noticed him or whether the supreme commander didn't want to notice him is difficult to say. But the major did not have his neck broken. Only the lieutenant suffered from diarrhea later on. The troop's morale, however, was superb. But if the general were to come again and were to notice the tall man,

it would probably be all over for the officers. Therefore, the major abruptly ordered the man to be placed under arrest. They could continually place Him under arrest if He were to refuse to make himself shorter. In the meantime the man had already grown a good deal once again. So the sergeant summoned Him and informed Him about the lieutenant's order: He had five minutes to reduce Himself to the normal size of the normal soldier. The sergeant waited. The tall man, however, did not reduce Himself. On the contrary, He actually continued to grow.

So, the sergeant now spoke about insubordination and placed Him immediately under arrest and sent Him to the jail. But after five minutes had passed, the officer in charge of the jail reported to the sergeant that the jailhouse was not large enough for the tall man. The matter was brought to the attention of the lieutenant, who was extremely horrified and reported it to the major, who, in turn, immediately ordered that a new jailhouse was to be built according to the dimensions of the tall man, who was ordered to wait outside until the completion of the new jail. The soldiers took his measurements as ordered, and they began to build the new jail at once. The entire company built the jail, and the tall man stood in front of the new building that was completed after three months. The major and the entire company were present when the man under arrest was to occupy the jail. But just think, in the meantime He had grown so much that He couldn't fit into the splendid and spacious new jailhouse.

Now the major was at his wits' end and gave notice to the lieutenant that the latter would have long since been fired if he, the major, were not such an affable person. The lieutenant was not to act like an ass. Even a simple man would have given much more thought to the matter given the chronic growth of the tall man, and he would have taken the inflation into account. By inflation the major meant the growth of the man. The lieutenant was desperate and displayed nothing but impressive obsequiousness in his attitude and expression. He received the order to have a new jailhouse built taking inflation into account so that the man could once more be locked up in three months.

The tall man stood in front of the new building and didn't move. In the meantime He had become so tall that one could easily see Him from some of the higher streets of the city. Like the rising moon on a hazy summer evening, He just stood and appeared more terrifying than the highest house. There were crowds of people and unrest. Therefore, some of the streets had to be temporarily closed for three months by order of the authorities so that the inhabitants would not unnecessarily be upset. The lieutenant summoned three educated and privileged draftees to his room and asked them who could calculate the inflation. Thereupon, the three first-year recruits figured out the man's inflation using log tables, calculators, and graphs. The man was measured once more. His size as base was multiplied with his inflation number, and according to this scheme an inflation percentage was found for the new construction of the jail. However, they didn't

take into account that the inflation construction would take more time than the previous building due to the greater dimensions of the new building. And although now four companies were put to work, the inflation building could not be completed within six months.

The man tall as a tree stood terrifyingly in front of the new construction. Yet the worries of the officers, who had the misfortune to be in charge of the project, gradually diminished as the inflation construction gradually neared completion. A small internal celebration was arranged for the opening. The major himself was present when the man under arrest was to enter the jail. The command was given: "Forward march! To the jail! March! Halt, at ease! Attention! Now march! Forward march! March into the inflation house! March!"

As ordered, He crossed the threshold but could not pass through the door because He had in the meantime become taller than the inflation house.

"Damn it all!" the major screamed at the lieutenant. "Who was the clown who made the mistake this time?"

The lieutenant gave all the details of the preparatory work and proved that they had calculated the right number for inflation and that they had carried out everything according to orders.

"I'm not asking about what you did correctly," the major said. "I'm asking who the clown was who made the mistake."

In response the lieutenant had the audacity to say, "Major sir, you gave the orders to calculate the rate of inflation for

three months. But since the jailhouse could not be finished within three months because of its gigantic dimensions, the man grew some more in the meantime."

The major turned red out of rage. Was he himself supposed to be the clown who had taken a shot and missed the mark, or was it possible for a clown to shoot at all? He certainly believed that it was possible, but only from a purely objective point of view was it possible, whereby it wasn't exactly clear whether he was the one who was the clown. And what was the mark anyway? He quickly reflected that he was not a numbskull like that character Auguste Bolte, and so he twisted his moustache like a spindle and ordered once again that a new jailhouse was to be built taking into account the man's growth and the inflation of time. And in general, they were to take into account the inflation of inflation in the construction of the jailhouse, whereby he was not certain what all this meant. The three educated and privileged draftees now calculated the value consistency of the man using an inflation table. Once again the tall man was measured, and they had to use a scaffold for this purpose. Just the calculation alone lasted fourteen days. It also took three months to build the scaffold. They had calculated that the entire army could build the new inflation jailhouse for the man in three and a half years, and then it would be large enough to house him. If, however, there were to be an epidemic, devaluation of the currency, or the eruption of a war, then the house would never be finished.

It was just then that a hoof-and-mouth epidemic began to spread among the cattle on the major's estate. In view of

this new difficulty, the major ordered that the hoof-and-mouth inflation rate should be taken into account. They had already been building the jailhouse for a year, and they had erected walls that were ten meters thick. To be sure, the tall man's official period of service in the army had expired in the meantime, but He could not be released because He hadn't served his sentence in the jailhouse. Now the foundation of the new jailhouse was so large that the royal castle with all its parks, fountains, naked marble statues, goldfish ponds, swans, rowboats, deer, orange orchards, and greenhouses could have comfortably fit inside, and this plan was just for a single room. The height of the jailhouse was calculated to be ten times higher than the tower of the church in the marketplace. During the first year, they had already raised the height of the tower five times its size. The tall man Himself had remained far behind the present height of the tower. Unfortunately, they missed this favorable opportunity to house the man because they wanted to finish building the jail before they did anything.

Once again, after a year, the building had been three-quarters finished, and that occurred just as the three educated and privileged draftees had calculated that it would become more difficult to build up into the air—the higher they went, all the more difficult. This is why the jailhouse was not finished after three and a half years, and when it was finally finished after five years, it was of course too small, yet once again. The major was desperate. The new jailhouse was sufficient, if it were necessary, to jail not only the entire army but

also all the people in the country. But it was once more too small for the tall man. So, what good did it do when the major called the lieutenant an enormous ass? That didn't make the jailhouse any larger. What good did it do when he said to the lieutenant, "If the new jailhouse had only become half as large as you, you enormous ass, you idiot, it would have been suitable for the man."

All of a sudden, the major thought that sometimes one also had to be objective in architecture. And since a suitable jailhouse definitely had to be built, otherwise the major could not be promoted, if the given order to jail the man could not be carried out, the major commanded yet another new jailhouse to be built according to his plan. He ordered the largest military drill ground to serve as the construction site to lay the foundation. It was an enormous desert of sand, and long-range missiles could be shot there. The tall man was to place Himself in the middle, and the entire army was to build the jailhouse on this site as high as possible so that it could encompass the man.

Since, by chance, there weren't any wars happening at that time, the general thought it was a good thing to occupy the army by having the soldiers build jailhouses. The supreme commander didn't know that only one large jailhouse was to be built, for he didn't take much interest in the matter. Indeed, the supreme commander incomprehensibly still didn't know anything about the tall man, whose position was on the flank, because the man's presence had been kept from him for obvious reasons. The entire army built the jailhouse

and worked on it day and night for ten years. In the meantime the tall man was informed that He was entitled to use the state health care benefits immediately after serving his time in jail. The walls of the jailhouse that were thick as a crater now reached the knees of the tall man. The world had never seen such a building as large as this jailhouse that was in the process of being constructed.

Since the major himself had built only according to his own discretion and had not taken inflation into account in his plan, the jailhouse was once again too small for the man, even though it wasn't even close to being finished. In the meantime the man had truly grown so much again that He now took up the entire interior of the dwelling with his thighs, calves, feet, leggings, and boots placing great pressure on the walls. The lieutenant continually rode around the colossal building and checked the durability of the walls. Enormous supports were built on all the sides. The major was still infinitely proud of his idea to construct the jailhouse around the man because it seemed it would restrain the growth of the tall man in any case.

Indeed, everything went well for a while because the man was only growing above the walls while He remained hemmed in below as if tied up to prevent any growth. He looked like a crammed-up chestnut tree, but now came the problem. They couldn't build vertically on the old walls any more, and therefore, they tried designing the building with protruding wood based on the architectural model of

Hildesheim because that would be the only possibility for them to finish the construction of the jailhouse.

By the way, Hildesheim is a wonderful old city. Next to Lüneburg it is one of the most beautiful of the old cities in northern Germany, very well preserved, easy to reach from Hannover by tram, an inexpensive Sunday outing. The chief attraction is a thousand-year-old rose bush. You wouldn't believe it. Just think, the little plant had already been alive one thousand years ago and is still blooming! It is one thousand years old. I'd like to see anyone do the same just once, become one thousand years old and still love and have children. And you can see all this simply by taking the tram on a Sunday morning.

But apart from all this, the Knochenhauer jailhouse being built around the man was said to be similar to the Hildesheim architectural type and had now reached five-eighths of two-thirds of one-half of the man's height. As a result of the lateral growth, they could not build horizontally anymore. To be sure, the major ordered them to build horizontally, but the three educated and privileged draftees, who weren't familiar yet with the modern cement architecture at that time, explained that this was impossible! A Knochenhauer jailhouse with Frank Lloyd Wright balconies would certainly have looked bad with the powerful upper body of the tall man towering over the entire construction. Suddenly the major ordered the soldiers to interrupt the building of the jailhouse. There was no question about it. The man could

continue to grow and blow the Knochenhauer jailhouse to pieces, and it wasn't possible to make Him responsible for this yet, because He was following orders. He just kept standing without moving, ten years, twenty years, thirty years, and He waited for new orders like a good soldier. Growing for Him was a law of nature, whether or not He received a lot or little to eat. And the major continued to be popular and affable. He was of the opinion that one had to explain people's mistakes as a result of their peculiarities and not punish them.

In the meantime there was another parade. The morale of the troops was excellent, but the general noticed that nobody was marching on the flank whatsoever. Indeed, the soldier who used to be there was not there because He was standing in the Knochenhauer jailhouse.

"Why?" asked the supreme commander.

"Because He's a little too tall to order about," the major answered.

"But that's no reason at all," the general asserted.

"If He, however, refuses to reduce Himself to the normal size of the normal soldier," the major replied, "then I consider in my opinion. . ."

"Since when is it fashionable for a major to have his own opinion?" the general interrupted. "I am ordering the man who marches on the flank to be released so He can join the troop."

A messenger brought the order to the tall man, who calmly received it, and He carefully tried to step out of

the jailhouse, but He couldn't do it because He was stuck. When the messenger reported this to the general, the supreme commander himself would not believe it because the supreme commander himself simply could not imagine it. Instead, he placed the messenger under arrest and set out on his own to the new jailhouse. What a glorious view! The general rode up front. The major was one hundred meters behind him, and the lieutenant, one hundred meters behind the major. They were followed by the entire officer corps ten meters apart from the noncommissioned officers and finally the entire army densely packed together. The general stopped in front of the Knochenhauer jailhouse and stared in astonishment at the dimensions of the imposing building in which he regarded the tall man Himself as a larger-than-life, true-to-nature, and highly inspiring dome. The entire army surrounded the building. The supreme commander looked for the entrance, but he couldn't find it even though he rode around the construction site three times to the right, and three times to the left. After he had done this, his excellency addressed the major and said, "Well, good heavens, what idiot conceived the plans for this construction? The entrance is missing!"

In response the major explained that the foundation itself was the entrance and drew the general's attention to the fact that the man under arrest took up the entire interior with his lower legs while He towered over the walls by 33 percent from his knees up. Now for the first time the supreme commander understood that the man under arrest was the

dome. Since the supreme commander had always suffered from varicose veins, he had a stroke caused by fright and dropped down dead, while the major and the army stood helplessly around the Knochenhauer jailhouse. All at once the major spoke: "Our supreme commander, the general, has dropped to the ground. He has dropped down dead. The army is under my orders. Now all ranks are to be promoted. I shall become general, the lieutenant, major; the noncommissioned officers, lieutenants; and all the common soldiers are to become noncommissioned officers. Mind you, this is to take effect immediately and retroactively."

But this didn't mean much given the widespread helplessness. The new general now consulted with the new major while the army surrounded the man under arrest. In turn, the arrested man grew, mind you, always taking inflation into account. All of a sudden the walls burst like an explosion, and the Knochenhauer jailhouse collapsed before the army could save itself. The entire army was now wiped out beneath the rubble. The new general and the new major were the only survivors, and they looked at each other dumbfounded and somewhat destroyed. Now the new general explained to the man under arrest explicitly that because of the death of the supreme commander, his blessed predecessor, He was to be promoted to become a noncommissioned officer but his sentence could not be considered served yet, and therefore the new general ordered Him to wait until the opportunity could be found for Him to work off the sentence.

Afterward the new general reported to the king every-thing that had happened. At first his majesty the king did not want to believe it because his majesty the king simply could not imagine it. Since his majesty the king, however, had never received false reports before, his majesty the king had to believe it, whether his majesty wanted to or not.

"And was my dear good friend and advisor, our supreme commander, the general, also killed in this unfortunate ac-cident?" his majesty asked with compassion.

"No," the new general responded. "The supreme com-mander, my blessed predecessor, suffered from varicose veins as it was, and he had a stroke when he caught sight of the tall man."

"Caught sight?" repeated his majesty the king, who turned pale from fright, for his majesty the king thought that Bol-shevik revolutionaries were involved. All at once his majesty ordered his son to appear before him and resigned in his fa-vor. New brooms sweep clean, and the new king was a dap-per officer. He ordered a new army to be stamped from the ground and formed right away, and the new general stamped a new army out of the ground with his feet right away. Next the new king ordered a military tribunal to be created right away so that the tall man could be tried and sentenced.

"To what?" asked the general.

"To death," said the king.

The military judges declared the man guilty because He had refused to reduce Himself. This was an exceptional case of insubordination that, as in cases of exceptional circum-

stances—and this was such an exceptional circumstance—demanded the death sentence. The tall man calmly accepted the verdict.

"I'm going to die. I knew it. Farewell, my brothers. I am ready to die."

The new general was sufficiently familiar with the evidence so that he knew instinctively the tall man could not be killed with bullets from a gun. Therefore, he armed every soldier with a machine gun. Upon the command, "1, 2, 3, fire," the entire new army fired at the tall man who used to march on the flank, but none of the bullets pierced his skin because it was much too thick. After ten minutes, however, the army was greatly decimated because some of the bullets had rebounded off the shiny brass buttons of the tall man's uniform. Once again, as in difficult times, all the educated and privileged draftees were called together to consult about how to kill the man whose position used to be on the flank. They proposed heavy electrical currents. The new general, who was always for the application of large doses, had all the electricity of the entire realm gathered together in two powerful poles. Then the tall man was commanded to touch both poles at the same time. All the electricity flowed through Him like a wide stream and leveled out without harming Him in the least. Indeed, it seemed to the general that He had also grown somewhat in the meantime. Now the young king, who was very much afraid of Him, hit upon the idea to order the tall man to commit suicide. But how? He couldn't hang Himself because there weren't trees large

enough for the task. Burning at the stake was senseless because all the firewood and fuel in the land would have barely been sufficient to warm his feet. There was only one possibility. The tall man would have to jump into the sea and drown Himself. So, upon receiving the order, the tall man plunged into the sea. However, since He had great layers of fat around Him, He didn't die, rather He floated on top of the sea. But the large splash caused the water to rise and to flow over the banks, destroying the coasts of every country that bordered on the sea.

Now the young king realized that it wasn't the tall man who represented a constant danger for the realm. Instead, it was his layers of fat. Therefore, he ordered the man to march day and night until the layers of fat were worn off. So now the man began to wander about. One step of his was approximately one latitude, and since He walked about incessantly, large sections of the country with flourishing cities were destroyed by his feet. But the young king didn't care about this because large sections of the country with flourishing cities had to be destroyed from time to time. This is why a civilized nation fought wars. The tall man's long march could perhaps save the country from spending money on too many wars. After fourteen days the layers of fat had disappeared. Now the young king ordered the tall man to jump into the sea. So the tall man plunged into the sea, and since He couldn't swim, and since He no longer had layers of fat, He sunk and drowned. Thereupon, the young king chose a bride and got married. ■

10. He shot it dead

## 9  Fish and Man

1) Once upon a time there was a fish. It swam in the large ocean, moved all the small waves, and splashed about in praise of our Lord.

2) A man came along and put on a diving suit and sprung right into the middle of the large ocean.

3) And when the fish saw the man, it thought, "The man is coming, and now there will be no more peace. He'll eat us."

4) So the fish sprang out of the wet ocean onto the dry tent of heaven.

5) However, it couldn't fly and almost fell back into the large ocean and almost drowned a miserable death.

6) Just then a bird flew by and was sailing in the large ocean of air and twittered and cheered and praised our Lord.

7) So the fish took away the wings from the bird and used them to fly to the firmament and twittered and warbled and rejoiced.

8) But the bird fell into the ocean and died.

9) A man came by and saw our fish high up in the air. It was enjoying itself by sailing and rejoicing and praising our Lord.

10) He shot it dead. ∎

And this is how
the story ends.

## 10　The Squinting Doll

Once upon a time there was a boy who loved to read fairy tales. This is how our story begins. And he was happy and cheerful until one day the idea occurred to him that a real princess might step out of the fairy-tale book and would welcome him. And a good fairy came, as she always comes to good children, and said, "My dear little child, you have wished for something that is dangerous to wish for. I'll fulfill your wish if you want me to, but you will fall under the princess's spell, skin and bones. That's my prophecy for you. And you'll become very unhappy because princesses don't love little boys. Instead, princesses love only princes. And it's no different in the fairy tales."

Upon saying this, the good fairy disappeared. But the boy pleaded and wept and became sick from yearning for the unknown princess, and all of a sudden he happened to see her, with blonde hair and blue eyes, sitting on a throne. And the boy's soul separated itself from his body and rolled slowly but surely to the feet of the throne and became the princess's slave, and the boy immediately realized that he was immensely in love with the princess. And his breast began to throb with pain. And the princess sat there like a marble figure and didn't take the slightest notice of the boy. The princess adorned her eyes with a veil, and the boy looked at the princess and wanted to find out what she felt for him. However, she was somewhere else in her thoughts and didn't take the slightest notice of the boy. Or perhaps she did notice

him? Perhaps she was still thinking about the affairs of the state, or she was relaxing after so much governing? Whoever governs the entire day becomes tired in the evening. Here the princess could withdraw from everybody. Here the princess was free from her court. Here she could be free with her thoughts. And the princess didn't always think like a princess, especially when nobody was noticing. And she took a doll in her hand and gave it to the boy and disappeared.

And the boy looked at the doll, looked at the spot where the princess had just stood and was no longer standing, and thought, "But is this really just a doll? Certainly this doll that knows all of the princess's thoughts is a living creature capable of understanding thoughts."

What could the doll do about it if it looked like a doll? Could the doll possibly answer the question whether the princess loved him and would make him her prince? And so he asked the doll whether it would tell him. The doll, however, was good to the boy because a doll is always good to children, because children always play with dolls, not like adults who set them in a corner and are possibly even rough with them. So the doll felt sorry for the boy and didn't want to hurt him, because she knew full well that the princess didn't love children. Rather, she loved only princes of noble blood. And the doll looked away and continued to look away in order not to hurt the boy, and so she started to squint. And this is how the story ends. ■

## 11  Three Suitcases

The express train was traveling through a desolate region. Three travelers were sitting in a second-class compartment— a businessman, an elderly lady, and a young chambermaid. The businessman said, "You know, in Africa . . ."

And the elderly lady said, "That's not for you, young woman, when I was young . . ."

But the young woman said, "Do you think that we young women today . . ."

The express train continued to travel through the desolate region.

Up above them on the luggage rack were three suitcases, a large brown leather suitcase with many hotel stickers, a medium-sized ladies' suitcase that seemed almost new, a very good large yellow suitcase that showed the strains of a long trip. And suddenly the three suitcases began to tell their life stories without anyone beneath them able to hear.

"People are strange," said the first suitcase, "and their feelings are funny. I belonged once to a German man, who said good-bye very lovingly to his wife in my presence, as he was about to travel with me far away to Africa. He kept waving good-bye for a long time, and then we were alone. I lived a long time with him in a dark corner and didn't know a thing except that it was hot. After many years had passed, the man was to travel back home, and I was taken out of the corner and filled to the brim with beautiful things. And there was also a woman, but she was black. They were very intimate

with one another, and the black woman wept and didn't want to stop. And when the man went outside for a moment, the black woman suddenly took a picture from her wall that looked like herself. She wrote something on the picture, kissed it quickly, and hid it hurriedly under some stuff from that country just as the man came back inside and kissed her. We set off for Europe, and the black woman accompanied us to the ship and said good-bye to my master just as lovingly as his wife had done some years before in Germany. Then she waved, and the man waved for a long time until we were alone. In Germany, the white woman picked us up from the railroad station. She greeted him warmly as if the man had never been away. Then we drove home in the car, and I was placed in a good room and opened up, and the man told his wife about all the things that he had brought her. And suddenly the picture fell out of the stuff. The white woman picked it up, screamed a terrible scream, and fell down as if she were dead. I never saw her again, and I wonder whether she was really dead. People are funny!"

"People are funny," said the third suitcase.

Then the second suitcase said, "I belonged to a woman who was young and beautiful. Now she is old. And she lived a lonely life during her youth, but she was not alone. A man visited her every evening in the room in which I stood, and each evening another man came. And all of them were very nice to her, so terribly nice. And she was very quiet and said nothing at all. And the men carried her into the bed like a little girl, and they were so nice to her, so terribly nice. And

people are funny!

when they went away the next morning, they gave her a good deal of money. And each morning the woman always gave me the money, and I became fat and heavy. Unfortunately, I had to remain hidden in a dark corner and couldn't see all the handsome men. But gradually the men stopped coming to visit her every day, and soon very few came. Then the woman stroked me and said, 'How nice it is to have you.' I was very proud about that, and the woman stood before the mirror. The next morning I received only a small amount of money. And from then on I received money, but only small amounts. After a few years the woman stood before the mirror and looked at herself for a long time. From that moment on I received an even smaller amount of money, and I didn't get this money every day. But I knew indeed that this woman loved me very much and gave me everything that she could. She didn't even have much more herself. I also loved her very much, and it seemed to me as if I were her dear bridegroom. When she was alone, she stroked me more tenderly than she had ever stroked one of the men. And then the doorbell rang, and a gentleman stood there. But the woman said, 'I'm sorry, but I'm getting ready to take a trip today. I need some peace and quiet.' The gentleman spoke a bit more, but then she closed the door on him and went to me and stroked me. That was the greatest triumph in my entire life. Then she went away for a half an hour to fetch something. No sooner was she outside, however, when the gentleman she had chased away opened the door with a duplicate key and quickly took all the money from me and packed it into a completely com-

mon, old cardboard suitcase. After he closed it, he rushed out the door. I was terribly frightened that he would also take me away from my bride, but fortunately he left me for her. I thought that the stolen money could be quickly replaced. I didn't want my bride to feel troubled that she had lost me. Then she came back and screamed when she found that the door was open. She rushed to me right away because she loved me most of all. But she didn't stroke me. Instead, she opened me so violently that I was flung high into the air. Then she screamed terribly and sank to the ground. The people in the building came running because of the scream and said, 'She's dead. It's better that way.' Then the entire room was searched by serious men. Indeed, I had never seen men as serious as these men before. Then I was brought to the court, and after some time had passed, I was auctioned off. Now I have a very fine mistress. People are funny."

"People are funny," said the first suitcase.

"Yes, people are funny," said the third suitcase and continued speaking. "I come from a wealthy house. A spoiled aristocratic young lady owned me, and she hid all kinds of precious things in me. She had a page who always brought valuable things to me and also fetched them from me. He was terribly in love with her as only young men can love with great passion and zeal. And she returned his love with tenderness and passion. And he was always with her and was always allowed to carry the train of her dress. One day a letter arrived from the Orient. Her father brought it to her and said that she had to leave the next day for a journey. A genu-

ine prince had sought her hand in marriage, and she had to marry him. She looked at me sadly, wept, and said that she could not leave her dear Denmark. She would die if she had to travel to the Orient. But her father said that he had provided for her long enough and she had not been a cheap daughter. Moreover, he would never get a better son-in-law, and she had to leave tomorrow. She had to pack her suitcase. And her only last request was to ask whether the page could accompany her, but her father wouldn't allow it. Instead, he decided that the chambermaid, who is sitting below us, would escort her, the young lady who is now taking me back with her. Then her father went away, and my young lady wept for hours, and the page wept on the train of her dress. Then she had to put on those ugly, short modern clothes and rose stockings, and I was packed with only those ugly new colors and stockings and slacks and shoes that our chambermaid always wore. Afterward we were ready to travel to the Orient to the genuine prince, who couldn't even speak Danish, the future husband of the young lady. Her father brought us to the train station, while the page could only wave to us from the house as we left in the horse and carriage. There were a thousand other suitcases at the station when we departed, but I heard what the chambermaid said, 'The bridal dress is here in this suitcase,' as she pointed to me. I thought, 'Are these rags really supposed to be the bridal dress for my mistress?' But when we arrived in the Orient, the prince picked us up from the station in a luxurious auto, and we drove to the greatest castle of the world. My mistress was happy. She

smiled and let the strange man take her into his arms. 'I had never thought that you would be so handsome and caring, Otto,' she said. Soon thereafter I was emptied, and the bride put on the rags and looked just like our chambermaid. But the prince admired her just as she was and dropped all his royal business and married her without thinking about it very long. Then my mistress gave me to the chambermaid as a gift. People are funny!"

"People are funny," said the first suitcase.

"Yes, people are funny," said the second suitcase.

Then the suitcases turned silent.

But the gentleman beneath them said, "Don't you also think so, young lady?"

And the chambermaid blushed when he said that. And just then the express train arrived at the Berlin station, and the elderly lady said, "Thank God that we are here at last. It's been unbearable for any decent person to hear your disgusting talk, sir. I won't have it!"

Then she took her suitcase and went into the corridor with her head held up high. But the gentleman said, "Would you like to dine with me in Berlin, my gracious young lady?"

"Very much so," responded the little chambermaid. "Right now nobody knows who I am in Berlin anyway."

And so the first and the third suitcases remained together for quite some time. ■

The old rooster
remains alone.

## 12    Fairy Tale

The rooster sits between three eggs. He is alone and feels lonely. He pecks and pecks and pecks even at an egg. A charming little chick comes out of the egg. The rooster is completely in love with the chick. But the chick goes off to take a look at the world, and the rooster is lonely again. He pecks at the second egg. Another charming little chick comes out. Just as the first chick sees the second chick, it runs immediately to the rooster, and both chicks swarm the rooster with their love. Now the rooster would like to have even more love because he's discontented, and he pecks at the third egg as well, because he hopes that another chick will come out. Instead, however, a little rooster comes out, and he is much more handsome than the old one, and the two chicks follow him. The old rooster remains alone.  ∎

## 13  A King without People

Once upon a time there was a king who didn't have any ministers. He didn't have any peasants. He didn't have courtiers. He had no one whatsoever, and everyone was satisfied under his rule and reproduced themselves by not having any children. This king lived in a splendid castle, but it wasn't a real castle.

It so happened that his majesty wanted to go up the stairs into the throne room, and so he went to the throne room filled with nothing but beds. They were piled on top of one another, next to another, under another so that he couldn't enter. And when he wanted to go downstairs again, he noticed that there were no steps. This led him to realize that he had not gone up the stairs at all. Therefore, he now wanted to stay below to gather his court around him.

The reason for this was that he expected an envoy from the neighboring people who didn't have a king because these people had a successor to the throne who didn't have a wife, because he was single, and he wanted to fill this present gap by courting the king's daughter.

However, the envoy didn't come, and therefore, the king held the following speech:

"Gentlemen, ambassadors of my royal neighbor, I am pleased that you haven't come to court my daughter. Therefore, I shall be glad to give you my daughter, for I don't have any daughters whatsoever. Tell your chief, the successor to the throne, that I am going to give his royal highness my entire love, my child, and half of my possessions."

At the word "possessions," his majesty the king thought twice whether it wouldn't be better to say he'd lend his possessions and to list what the half of his possessions were. Since he didn't have any possessions at all, however, it didn't make much of a difference if he gave away half. The other half would be sufficient for his old age. ∎

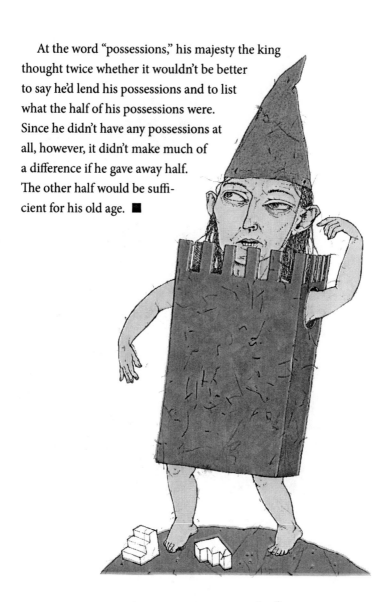

... he, however, didn't have any possessions at all...

the sky became
black with mosqitoes

## 14 The Story about the Good Man

Once upon a time there was a good man who was happy about his life. Then a mosquito flew by and landed on his hand to suck some of his blood.

When the good man saw the mosquito, he knew that it wanted to suck his blood, and he thought: "The poor little mosquito should suck my blood until it's full," and he didn't disturb it. Then the mosquito stung the man, sucked his blood until it was content, and flew away totally grateful. It was so happy that it told all the mosquitoes how good the man had been and how good his blood had tasted.

Then the sky became black with mosquitoes, and they all wanted to see the good man and suck his good blood.

And they stung and stung and sucked and sucked, and none of them became full because there were too many of them.

Meanwhile, the good man died. ■

I bring you great
news of joy

## 15 Happy Country

It was as if the king, great and powerful, had risen out of a fairy tale to new glory.

Then the dams formed a circle. The trees grew so large that their peaks protected the house.

It was as if the fairy-tale king said, "My people! I bring you great news of joy! In my royal realm, nobody will need anything. In time my true people will live in their houses softly bedded down on an island."

Then spring came and shook its blossoms over the small happy country with great zeal. ∎

So this was the rabbit

## 16 The Story about the Rabbit

Once upon a time there was a brown rabbit that had long hair and long ears and a short tail, and it hopped around the corner. It also hopped around the corner even when there wasn't a corner to hop around. Actually it wasn't brown, but rosy, and its hair was actually short, and its tail was curly. And actually it didn't hop at all but grunted and dug in the mud. Then it looked muddy and no longer rosy, but rather dark gray red. And if it had small piglets, they suckled on the rabbit. However, actually it wasn't gray red, rather gray white, and it had many feathers and a pair of beautiful wings, but it couldn't fly. On its legs it had flippers and it swam proudly on the pond in the park, and people who walked by threw it bread crumbs. That is, actually it swam underwater, had golden scales and a tail with two points. That is, actually it didn't have much of a tail; rather, it had two ears and was very fat and preferred to spend a good deal of time in the Nile River. Its mouth had a magniicent row of teeth. That is, actually it was driven by steam, had a propeller behind it and two anchors in front. In the middle there was a chimney, and on the bridge there was a captain who belonged to a Hamburg shipping line. That is, actually he was very small, liked to jump as far as he could, and sought protection underneath the clothes of women, and the women scratched themselves. So this was the rabbit, and this was the story about the rabbit. That is, actually it wasn't a story at all, but a transformation that even made the rabbit grow up.

Well then, it was a story, and it was indeed also about a rabbit. ■

if only I had remained
as I once was.

## 17 The Three Wishes

Once upon a time there was a man who wanted something, only he didn't know what. However, he at least knew that whatever he wanted had to be special.

One day he encountered a hunchbacked old woman, who said, "Young man, I see that you want something."

The man was astonished that she could see this, and he said, "You're right, my good woman, but I don't know exactly what I want."

Then the old woman replied, "I know what it is, but I won't tell you. I have the power to grant you what you want and will give you three wishes. Each time, your wish will be fulfilled. But you may only wish something from me three times. So be sure that you make smart wishes."

Then suddenly there was a puff of smoke, and the old woman disappeared. However, the difficult part was about to begin. Just imagine that you are suddenly granted three wishes. You probably wouldn't know what to do. Most people would probably not know what to do.

The man began to consider all that one could possibly wish for in life, and then he realized what he wanted. It was happiness. But he thought some more. If he were to wish for happiness, then the old witch could give him some trash and say that it was happiness. For instance, she could confuse his feelings so that he might believe he was basically happy the way he was. No, he refused to have anything to do with such a swindle. He wanted to have something solid, a happiness that

would be the envy of others, since happiness is only that which others also want to possess.

And so it occurred to him that a person had to define the notion of happiness more precisely if one really wanted to be happy. Thus he wished for wealth.

All of a sudden, he was rich. The gigantic castle in which he lived was teeming with servants. He lay in golden pajamas on a tremendously large bed, so soft that he could no longer even feel it. A servant handed him a tiny cup of mocha on a thin reddish tray, and the mocha was so strong that a heavy teaspoon could stand up straight in the cup. The drink was sweetened with saccharin, and the servant was dressed in a uniform of ivory.

However, the man in bed said, "Is this the best you can offer me?" And he kicked the tray with his violet felt slippers so that the teaspoon flew and hit the ivory-liveried servant. Then he jumped out of his large feather bed and shouted fiercely, "I'll show you what a rich man is!" He took one of the three hundred and thirty telephones that lay next to his bed and ordered all the pianos of the world to be delivered immediately and had them dumped in a nearby river. That was the end of piano music, and the traffic of the boats on the river was blocked for months. But this did not disturb him in the least.

On the other hand, it didn't make the man happy. So he meditated and then gave the strangest orders. He had all his servants bathe in chocolate. But this, too, did not make him happy.

Then the old woman appeared beside his bed and said, "You made the wrong wish, but you still have two more. Choose the

right one, and you'll be happy." And again there was a puff of smoke, and the old woman disappeared.

The rich man felt quite unhappy, for he didn't know what the devil he should wish for. What was there that could make a man happy if wealth couldn't do it?

Suddenly he knew—world power.

And in a flash, he was the mightiest king of all time. He ruled not only the earth but the cosmos. The electrons from the most distant planets came to glorify him. His name stood on all the dishware and was broadcast constantly on the radio by the propaganda bureau. His was the only name there was. Rich and happy people no longer existed.

He himself no longer lived in the large, soft feather bed. Rather, he had his bodyguards build him a house made out of atoms between the earth and the moon, where he spent all his weekends. Yet all this power did not make him happy. He became bored because, unfortunately, there were no more wars. Therefore, he had two great planets crash together for a change of pace, and the reason he gave for this was that he didn't like the noses of the people on one of those planets. But what was the use of all this? The blast was great, and the flames even greater. Yet after the excitement died down, he became bored once again. He needed something that would last. That's why he had glowing meteors hung over the heads of his subjects so they would live in constant fear, and all this was done just to please him. But soon he had these meteors dismantled, because they were no longer fun. And so he thought and thought how

he, the world ruler, had been deprived of good entertainment, and he almost wished for an enemy so there would at least be a war. Just at that moment the old woman appeared next to his bungalow and told him that he had made the wrong wish, but he still had one more. He had better think more carefully and choose the right one this time.

Then there was the puff of smoke, and the woman disappeared. However, the man remained troubled because, God help him, it seemed that there was nothing better in the world to wish for than all the power in the world.

By chance he overheard one of his bodyguards saying something about one of the other bodyguards: "Yes, he's got it good. He can take anything. Nature's given him an even temperament, and he feels just as happy as a fish in water." Then the man pointed to his forehead with his index finger and said to himself, "Use your head!" And he was happy that he had finally hit upon the right wish. Naturally, fish, they've got it good. They feel happy just to be in water. Why should it be any other way? They wouldn't feel so well in air. He finally knew how to use his head.

And so he wished for the shape of a fish. And within seconds his shape changed, and he looked like a fish. Then he had himself lowered so he could spring headfirst into the river. But the water was wet, and he had so much trouble breathing that he doubled over and gasped for breath. Indeed, he was speechless and couldn't even complain, because he had been given the attributes of a fish but not its nature. He opened and shut his mouth as though he wanted to say something, but all fish do

this, and not a sound is heard, though they try very hard. Then he thought that the story about a fish in water was a fairy tale. Fish only seem to be happy in water. At any rate, he did not feel happy as a fish. He couldn't shed one tear about his bad luck, for everything around him was water, and his tears could not be seen. Then a school of small fish swam by in a hurry, fleeing from some larger fish, and this made him shiver all the more. Next he saw a fish being eaten by a water lily and wriggling softly. Finally, it occurred to him: "If only I had remained ruler of the world! Most men never have the chance in a lifetime to become as powerful as I was. Or, at least, if only I had remained as I once was!"

And suddenly the old woman reappeared, swimming next to him. He became happy and followed her to the surface, where he was immediately changed back into his original shape and became an ordinary man.

Then the wise old woman said to the young man, "You've chosen the way most other men would have chosen, since they all seek happiness outside themselves. You've now seen that happiness does not lie just anywhere. It can only lie within yourself. Remember, too, that others also want to be happy. Then be happy, and you'll be able to make others happy too."

All at once there was a loud blast, and the old woman disappeared. This time there was a smell of brimstone. ■

...all the girls who knew
him fell in love with him.

## 18   The Ugly Young Woman: A Fairy Tale

To be sure, one can't argue about the terms "beautiful" and "ugly," for they are matters of personal taste. Indeed, one cannot convince anyone that what he finds to be beautiful or ugly isn't indeed beautiful or ugly. And there are people who are recognized by so many other people as beautiful or ugly that one can objectively call them ugly without worrying about it.

Those people, designated as ugly, have to bear a great deal of grief, things about which beautiful people often have no idea, things that they do not see or suspect, for everything goes well for them. They live in the illusion of happiness acquired without having earned it themselves just because they have had the good fortune of having been born beautiful.

In the meantime those people who have been equipped by nature with fewer gifts of beauty are often much more vital. In fact, nature is always wise and just toward us human beings, and as a reward for the lack of beauty, it gives ugly people important intellectual gifts that the handsome person does not possess.

Those ugly people are precisely the ones who don't yield passively to their fate. Instead, they confront the world cou-

rageously, and instead of losing heart, they work on themselves and cultivate and increase those good gifts given to them by nature—they are the ones who develop integrity and strength of character that are always most valuable in this world because they are so sought after. This is why you often find ugly young women in the most responsible positions in offices. In fact, they are the most conscientious and finish all their work with loving care. And often those men who control the fate of many people can be called neither handsome nor interesting, but they are the ones who are important people, the valuable people, not those successful ones who are carried by the favor of many and who only view themselves and cannot see life, work, or fate.

The beautiful young women seem to have it easy in life. They are very much in demand and can afford to appear proudly while they ruthlessly choose their admirers. And yet they don't have an easy time finding the means with which they can successfully shape their lives in old age. For the most part they become hard and unapproachable, and since their beauty does not last over time, they then have nothing but their memories.

Many men are also often in demand, just like these women. Not the beautiful men because women do not esteem beautiful men, but rather the interesting ones. Yet it is actually difficult to say what makes these men interesting. They aren't intellectually stimulating, nor are they clever. They have little success in their professions, but women find them interest-

ing. The most beautiful women go to great trouble to win their favor. One can, however, only feel sorry for such men, for they don't have the time to work on themselves so that they mean something in life.

Rolf was such a handsome man. The beautiful girls blushed whenever he entered the dance hall, and the ugly girls did not in the least dare to look at him because he never had a friendly smile or a kind word for them. Perhaps it was his fashionable name, Rolf, that made him so handsome and increased his attraction, and thus he was, without exaggerating this observation, a worthless human being, vain, without culture, and always self-satisfied. In short, he lacked the ability in his profession to work on himself, nor could he. His good tendencies withered in the intoxication that he experienced as the admired, interesting man, and he passed his youthful years away by dancing with beautiful but boring and heartless petty women.

But such intoxication doesn't last forever and isn't satisfying. Instead, it ignites the continual longing for new experiences, and when these experiences do not offer anything new, the result is boredom.

Rolf was very bored, for he no longer had any new experiences with beautiful women, and he had no reason to love his daily work. And soon everything became blasé for him. Everything began to feel the same.

If one wants to save oneself from such a condition, one has to have fantastic ideas, and Rolf generally had them. His

girlfriends laughed at him mostly because of his crazy ideas that he tried out, and they knew that he would soon recover from them.

As a refined Don Juan, Rolf loved to be surrounded by many women at the same time and to play them against one another. It tickled his ego to see young women suffer because of him whenever he seemingly favored one over the other.

One night, while attending a dance and surrounded by the most beautiful women at the ball, he felt bored and tired of life, and just as he was thinking that he'd make Erika jealous by favoring a less beautiful young woman, Erika suddenly said, "Rolf, could you ever love an ugly young woman?"

"Never!" Rolf replied, as if it were self-understood.

"But, could you dance with her?"

"Dance?"

"Dance with her?"

"Well, hypothetically, yes. But I would stand her up and then choose a beautiful woman."

"And if we were to bet?" Erika continued to ask like a stubborn child who wants to pursue an absurd idea to its end.

"Why should we bet? I said yes, I can't do it, and I wouldn't do it."

"And I bet that you can," responded Erika with a suspicious look at Susi, that beautiful woman Rolf was presently favoring with his attention.

"Am I supposed to be something like a scarecrow?" Susi asked because she felt insulted.

"My God, our tastes are really different!" Erika answered.

And right at that moment Rolf suddenly realized that he could very well dance with an ugly young woman. Indeed, just then he felt disgusted by the petty arguing of the beautiful young women.

"You don't have to bet, Erika," he said firmly. "I agree with you. I can very well dance with ugly young women."

Then he stood up and walked across the dance hall. All eyes followed him. The beautiful young women were on tenterhooks and watched to see which young woman he would choose as especially ugly. ∎

... he took a club
and beat Isaac
to death.

## 19    The Two Brothers

Once upon a time there were two brothers. One was smart, but he was not so good at chopping wood. The other was strong. He could rip out trees, but for all that he wasn't good at thinking.

When their father was about to die, he called his two sons to his bed and said, "You're both dear children. You, Isaac, are so smart, and you, Henry, are so strong. When I die, I'm going to leave you my little house and my little field. It should be enough for you if you work together. But if you should divide the small property, it will not be enough for either of you. And now I'm bequeathing you this small property under the condition that you get along with one another and that you support your mother and give her what she's been accustomed to."

Then the father died. And the next day, Henry said to Isaac, "I think it's best that we divide the inheritance this way—you leave this place, take our mother with you, and support her, while I work the farm and live in the house."

"But how am I to support our mother," Isaac asked, "if I don't have any income from the farm?"

"You should know better than me how to get along," Henry answered. "You're the smart one."

Isaac endeavored to make it clear to Henry that their father hadn't meant to divide the inheritance in this way. Rather, they were supposed to work the farm together. Then the farm would support them both and their mother as well.

However, Henry believed that Isaac thought he could trick him because he was so smart, but he wasn't as dumb as Isaac thought, and he knew that a farm could not support three people better than one. And when Isaac wanted to say something more, Henry threw him out the gate onto the road and also kicked out his mother.

Now Isaac and his mother went to the father's grave and prayed, and a wealthy farmer came by and asked why Isaac was weeping so much.

"I've lost my father," Isaac said, "and my brother has chased me off the farm and has also banished our mother. Now we're both in the cruel world and have nothing with which we can support ourselves. This is why I'm weeping so much."

"Come with me," the stranger said. "I have a farm, and you can work there so that you can support your mother and yourself."

Isaac thanked him very much and began working at once, and he liked everything he did. Since he worked diligently, the farmer was very satisfied with him and gave him a good salary so that Isaac soon had a beautiful home for himself and his mother, and he could marry the farmer's daughter, Velia.

One day the farmer asked him where his bad brother, the one who had abandoned him, was living. Isaac responded that he didn't want to say, but he did say that his brother wasn't bad, just dumb.

Some time later Henry showed up at the farm looking for work, and when he saw his brother Isaac at the dinner table, he said, "Well then, if this old man has given you work, I unfortunately can't work here."

Now the farmer recognized who Isaac's brother was because he had overheard the conversation. And he said, "Isn't that the strong man who recently tore out the German oak tree at the fair and won a prize?"

"Yes, he's very strong," Isaac said, "but he doesn't think about the consequences of his actions. The oak tree won't be able to grow any longer because he's ripped it out of the ground. Even if he were to replant it, it won't be able to grow anymore."

Years went by, and the mother became sick, and as she was about to die, she wanted to see Henry one more time. Therefore, Isaac went to him and asked him to come because their mother was sick and about to die. But Henry said, "Our mother let herself be supported by you, and so I can't come to your house and to a person who's dependent on you. And what will our mother leave behind her? Your wife can wear her clothes, because I don't need them."

Then he threw Isaac off his farm and told him that if he were to bother him again, he would cut off his fingers because he couldn't cut off his intelligence.

Now Isaac told his mother that Henry was sick and couldn't come in person. But he sent his regards as son. The mother was despondent that she couldn't see him, but she

was happy about the regards and wanted to know how things seemed on the farm where she had been so happy.

So Isaac said that the farm appeared to be flourishing just as it was before. Everything was beautiful, the land had been cleared and cleaned, and thus his mother was happy. It was his way of saying that Henry had ripped up all the trees and that nothing grew on the entire land that had been evenly leveled.

After the mother died, Henry came to Isaac and said, "You must help me. I've worked on our farm and done what I could for you and me. But the yield is not entirely sufficient because the plants won't grow on my beautifully leveled land. I need money." So Isaac went to the wealthy farmer and asked him to lend his brother some money. But the old man said, "Since he's not treated you as properly as he should, I'm not inclined to give him any money."

So Isaac went to his brother, who was waiting for him nearby, and said, "The farmer can't lend you anything at this time, but I'll help you out a little," and he gave him a hundred dollars.

"What am I supposed to do with a hundred dollars?" the brother Henry said. "I'm not a simple beggar! And the farm belongs to you as much as it belongs to me. If it doesn't yield much, you're obligated to help as much as you can. Therefore, you've got to give me all your savings right now. Otherwise, I'll tear you to pieces."

Partly out of fright, partly out of love for his bad brother, Isaac fetched all that he possessed and gave it to Henry. In

turn, Henry said, "Now you'll see how grateful I am. If you hadn't given me everything, I would have torn you to pieces, and that would have hurt. However, since you were so nice and gave me everything, and since you no longer have anything to give back to me, I'm going to kill you as a good brother should because that way you'll die quickly." And he took out a club and beat Isaac to death. When the wealthy farmer heard this, he telephoned the police and had Henry arrested.

A trial was set, and Henry was accused of murder. In his defense, Henry said, "To be sure, I've killed my brother, but not out of evil intentions, rather out of love, because after he had given me everything, he himself had nothing more to support his life, and I killed him so that he wouldn't have to rot away and die miserably."

The judge responded, "Very well, my son, you've acted in good faith. And we shall treat you also in good faith. You see, now that you don't have a brother any more from whom you can steal and who can give you his savings, you might starve from hunger if we were to send you back to the farm that you've leveled. Therefore, we're sentencing you to death."

When Henry was about to be executed, the executioner asked him whether he had a last wish. Then Henry said that he wished all the farms in the entire world would be leveled as flat as his farm was, and that all the trees would be ripped out of the earth. But the executioner told him that he couldn't promise that his wish would be granted. ■

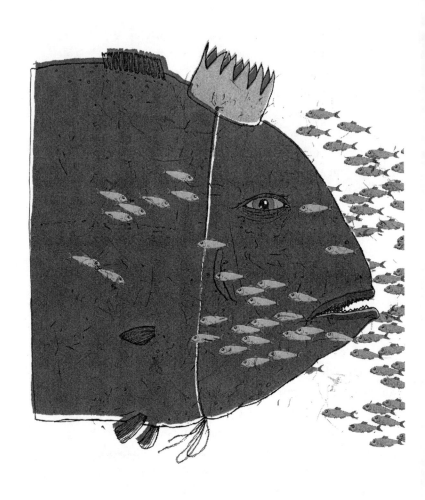

"Hail to our leader".

## 20  The Fish and the Ship's Propeller

Once upon a time there was a fish that ate so many huge things that he became completely fat and heavy. One day he swallowed a big propeller of a ship, and the iron weighed so much that he could only wobble on the bottom of the sea. Now the other fish came by and laughed so hard that the algae vibrated. They poked him with their sharp noses in the side where he was ticklish, and they behaved in all sorts of vulgar ways. All at once a large ship swam above the fish, and a net was lowered into the water and dragged along the bottom of the sea. All the fish were caught. There was a horrible wailing and moaning.

"What can we do? What can we do?" the fish yelled desperately, and those very fish that had been the most uncouth asked the heavy fat fish for his advice.

"Take it easy. I'll turn things around!"

And as the net was to be pulled up, the fat fish laid himself on one side, and the net tore open, allowing all the fish to swim through the hole. In the aftermath the fat fish was proclaimed king. A crown of mussels was bestowed on his head, and as the band played the melody "Hail to our leader with the victor's garland," all the fish marched by and saluted him. ∎

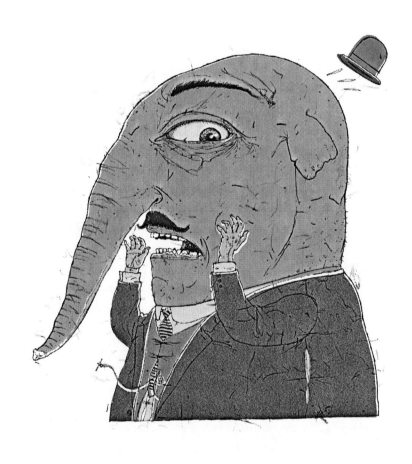

"Actually he's just
an elephant anyway."

## 21  Transformations

Transformations occur very often in fairy tales, and one thinks little about them. They are just those familiar transformations that are undone anyway by the end of the fairy tale. The evil magic leads to a good ending and so on. But who thinks about the fact that they involve considerable disturbances in one's professional life? Who can imagine oneself in the position of a poor person who has been changed and then, instead of paying rent, spews horse dung, or instead of singing, can only peep if he has luck? Others bleat disgustingly like sheep or butt with their horns when they want to argue. No one ever thinks of meeting such a fate, even though the sorcerer can be found wherever life is most vibrant.

Who hasn't read about that sorcerer who transformed all the customers of a department store, all the employees, supervisors, and guards within a circumference of fifty meters into sheep with a single magic word at the busiest business season during Christmas, and to make matters worse, on a Saturday afternoon? While he did this, the sorcerer changed himself into a dog that barked terribly and drove the sheep out of the store. It was in all the newspapers for everyone to read. Everyone thinks that he himself would not be suitable enough to be changed into a sheep until he notices that he

has already long since been transformed. Of course, the reason is clear, for the dog of a sorcerer has long since taken the safe and made off with it to Siberia. The poor transformed sheep, however, remain sheep for the rest of their lives, unless a prince comes to save them. And it is nearly impossible to describe all the bleating in a large city when millions of sheep rush about, and whoever has not yet been transformed into a sheep should just thank his lucky stars.

But it's not just sheep that one can be changed into, but also oxen, for example. Afterward they knock down everything without any reason and without blinking an eyelash. They show their brutal horns and charge at everything since they are disturbed by everything. Then there are others who live as pigs in the gutters for the rest of their lives, if the prince doesn't come and find the magic words to release them from the spell. Whoever becomes a hen can at least be useful by laying eggs, and whoever becomes a stork can bring babies from time to time. He just must make sure that he doesn't go to the same house too often. It's quite clear that these eternal transformations greatly disturb the normal life of a big city, and it is indeed the damned duty and responsibility of the municipal authorities and the police to try to work together to counter such crimes.

As I was in the midst of philosophizing like this, I crossed a not very busy street to buy my breakfast, and I encountered a man, something that can happen to anyone anywhere, and it would never have occurred to anyone that this man might have been a sorcerer.

Well, this man asked me when the next tram was leaving, and I forget the direction that he asked about. So I politely took out my pocket watch to see what time it was, and suddenly the watch was gone. The man had used magic to make it disappear in an instant.

"Well then," I thought, and my face turned bright red with fever, "what's happened to my watch?" Now it's well known that sorcerers can read thoughts, and since the man noticed that it might soon become uncomfortable for him, he hit my chin with an upper cut so that I immediately became dizzy and staggered against the wall of a nearby house. I stood there with my empty stomach—indeed, I still hadn't had breakfast—for some minutes before I regained consciousness, and of course, the man had used the time to make his getaway.

Soon I became more aware of the situation, and there I was standing and had apparently crushed the grill to the door of a barbershop due to my very unusual weight, for the man had been a sorcerer and had transformed me into an elephant.

"What a horrible situation!" I thought. "Who's going to pay for the crushed door?" And I didn't dare to move myself any more so as not to cause even greater damage. All around me people began running about. I wanted to talk to them, but I could only utter some inarticulate noises. "Thank God," I thought. "At least I've become a breed of animal with higher standing," for it's generally known that elephants are smart animals. It was unclear to me, however, what was going to

come out of all this. Where was I to stay? In no way could I return to my apartment. Everything was too small for me there. For example, the entire toilet was not even one tenth as large as I was myself. Or just think, if I had wanted to take a bath in my bathtub, how the water would have sprayed out from all sides. Consequently, I left my thoughts about my future to fate, for one does well not to intervene in the spokes of the wheel of destiny. Anyway, how could I have brought off such a thing with my considerable, thick paws? I would have destroyed the entire wheel at once.

This is why I thought, "Take a little walk for a while." So I took my hat, . . . uh-oh, naturally I didn't have one any more. I must have just been mistaken. So, I took my four thick paws or claws—indeed, they weren't hoofs—and I began setting them down carefully one after the other, and it worked, because elephants are always careful. But you should have seen the crowds of people push each other out of the way when I approached.

"You're drunk!" the people yelled, because I tottered, not being able to master such a powerful mass of flesh by my relatively small brain. And when I leaned against the nearest show window, you should have heard the people scream. The glass of the show window rattled until it finally cracked open, caved in, and crashed. The worst of it was that it was a pure Aryan store. Naturally the mob didn't care, and since the glass was broken anyway, they stormed the shop and plundered everything, the tiniest thing. Indeed, they fought over the fine sausages that were on display, and I thought: "It

can't go on like this!" So I filled my long trunk with the water that happened to be in the gutters and sprayed the crowds of people.

"That can cause stains!" a woman shouted. She was carrying twenty pieces of salami under one arm, but I gave her another shower to cool her off. Then I took the pieces of salami and crushed them because I found it disgusting to eat salami, even though I was very hungry.

In the meantime the firemen arrived. They were the first ones people called in emergencies like this, and I was sprayed from all sides. That was very pleasant for me because I was a bit excited as it was. I only thought: "Actually the firemen are somewhat cheeky to spray anyone, especially because they weren't born with natural trunks for spraying." As a result, I took my natural hose filled with gutter water up to my nose again and squirted the water at the firemen. That went on for many hours until all the firemen were dripping wet from top to bottom, and I could hold out very well because the firemen saw to it that I always found enough water there.

Everything would have lasted even longer if the police had not finally intervened. At first ten officers came in order to determine my identity and take down particulars. I grabbed their notebooks and swallowed them. Then a hundred officers came, and they kept a good distance from me. However, I could easily reach them with my long spout, and I ate up one notebook after another because I had gradually found them tasty and had become quite hungry. Now a thousand security officers came from all sides with shiny weapons, but

they didn't have the success that their superiors had wished. I took away their small swords one by one and broke them into pieces with my trunk.

Naturally that caused the police to become very bitter, but I enjoyed this, and after I had broken all the swords, I went over to them and lifted the officers one by one and wrapped them around lampposts until the miserable fellows fell down. This is how I occupied myself for many hours since the army didn't dare to intervene. If they had, they would have destroyed all the houses around me with their cannons.

Then came a circus trainer who was used to dealing with lions. Naturally I smelled a rat right away because he had a whip in his hand. The trainer took a position far from me on the other side of the street and said, "Come to me, my little one. I won't harm you."

I became furious and wanted to give him a piece of my mind and took a step toward him. Well, you should have seen the trainer run with me right after him! Finally, I overtook him, and as he dropped his whip, I picked it up with my trunk and whacked him right and left with it until he fell down.

There I was standing right before a place that was selling fir trees for the coming Christmas holidays. I bought up the entire stand without paying and ate all the trees because I couldn't satisfy my appetite just from the notebooks of the police officers. I had never tasted anything so delicious in my life up to then. But I was still hungry because I had done so much. So I slowly ate the entire wood frame of a villa, one

piece after the other, and this house belonged to the mayor, who became enormously frightened because he couldn't live without wood shutters. He picked up the telephone and asked to be connected immediately with the treasury department responsible for magical creatures.

They told him that, up until then, they had never broken the magic spell of elephants, but they would try, especially because he was their superior.

So five men from the disenchantment institute came and formed a circle around me. Then they began uttering their magic words. One of them said for hours, "dog taxes," another, "tax payments for the canal," the third, "interest on your property tax," the fourth, "duties for the roads," and the fifth, "entertainment tax." And as they continued to say all this in a chorus without interruption, I lost one kilo after another until I stood there completely thin and lean, almost shriveled into a skeleton, but still an elephant.

Then suddenly, as if upon a signal, they all began to say, "old age pension, old age pension, old age pension." And all that brought back my former shape to me. I was once again a middle-aged man. The only thing I lacked was my watch, which the sorcerer had caused to disappear through magic. I leaned on the wall I had staggered against when the sorcerer had dealt an upper cut to my chin, and a charming nurse was bent over me with a bottle of smelling salt in her hand.

"Now everything will soon be better," she said with a pure chiming voice that I had never heard ring so beautifully

before in my life. Then she signaled two officers, and they placed me on a stretcher. I was lifted into an ambulance and said, "But only if this young woman comes with me."

"Don't worry. I'm coming," she said and sat down next to me in the ambulance while I lay there and held her hand in mine.

Well before the ambulance reached the hospital, we became engaged, for I very much wanted to marry the young woman so that she would at least get my pension when I died. The next day I was released and considered to be cured, and on the third day the marriage took place. On the very evening of the third day, we traveled together to Venice, and while we took a ride in a gondola on the canals, we still spoke about my transformation into an elephant. Then my young wife said with a laugh, "When I really look at you, I still think seriously, sometimes even today, 'Actually he's just an elephant anyway.'" ■

## 22  He Who Is Mentally Retarded

Once upon a time there was a fisherman who lived with his wife on a desolate island out in the fjord. They were a God-fearing couple who had never done anything bad in their lives. The fjord was full of fish and lobsters, and the fisherman and his wife could live well and did not need to worry. There was a small town on the coast of the fjord, and the fish merchants lived there. They, too, never had bad thoughts and were just like well-trained domestic cats. Contentment and affluence reigned on the island and in the town.

One beautiful day, the fisherman's wife said to him, "Soon it will be time to mow the grass. We'll need help with the hay, and you'll need help when you fish and bring your catch into the city."

"Quite right," answered the fisherman.

"Why don't we try getting some help from one of the mentally retarded men, someone from the dumb town who's strong and willing to work? The communal funds will pay for us to have him, but he won't know a thing, and it would be a good deal for us to have extra help."

The fisherman considered this an excellent plan and looked around for a useful retarded man. After he had found the right one, he took him to the island and had him mow the grass.

But his wife was still not satisfied. "We need money," she said to her husband. "Everything is so expensive nowadays, and even though it's the season when it's illegal to fish for lobsters, it would be a good idea to fish for some now. The hotels are full of tourists who don't like it at all if they can't get lobster to eat. Don't think about the law. Nobody cares. You'll only be doing some good if you make the tourists satisfied, and besides, everyone earns something if you do this."

"Don't you think that the idiot might say something?" the fisherman answered.

"Of course not! He's got a head made of wood and doesn't understand that it's against the law."

And so the next night the fisherman sailed out into the fjord with the idiot as his helper, and they made a good catch. The fisherman was really happy as he thought about all the money that he would receive for the lobsters, and when he went to bed, he dreamed only of lobsters and high prices.

But the idiot also thought about lobsters and high prices, and when the fisherman woke up the next morning, he discovered that not only the idiot had disappeared but also his boat and the lobsters.

The idiot had simply gone straight to the first fish merchant he saw and said that he had lobsters.

...into the tank.

"I'll take them," the merchant said. "But for God's sake, don't tell anyone."

The idiot promised to God. Then both of them went down to the dock where the merchant examined the lobsters and paid a good price for them. The idiot rowed over to the merchant's fish tank and, covered by the morning fog, he dumped the lobsters into the tank without great difficulty, while the merchant stood on the dock and looked around somewhat uneasily to make sure that nobody saw him.

But the idiot hadn't really dumped the lobsters into the fish tank. The merchant couldn't see this from afar because of the fog. Instead, the idiot had pretended and moved on to the next fish merchant. Just like the first one, this merchant was also happy to get some lobsters. He gave the idiot a good price, went with him to the dock, and kept guard while the idiot tricked him with the help of the same morning fog.

The idiot continued to sell the illegal and stolen lobsters the same way to a third, a fourth, and a fifth merchant until there were no more merchants left to trick in the small city. In the end the idiot took the lobsters to the communal kitchen, where he sold them at a very low price and really delivered them this time.

Toward noon the first merchant heard that the communal kitchen had lobsters. Where could they have come from? He rowed out to his fish tank and found it empty. There was no doubt about it. He went directly to the communal kitchen and asked, "Where did you get the lobsters from? They've been stolen from my fish tank!"

But the people at the communal kitchen simply informed him that they had bought the lobsters from the idiot.

In the meantime the second merchant had sold his lobsters to the large hotel in the city that needed the lobsters for the tourists. But when he rowed out to his fish tank to fetch the lobsters, he found the tank empty. On his way back he met the first merchant and exploded, "This morning I bought fish from the idiot and stood and watched as he dumped them into my tank. And now the tank is empty!"

"The fish were, to be sure, lobsters," the first merchant answered with an ironic smile. "I, too, bought lobsters this morning from the idiot and watched as he dumped them into my tank, and now it's just as empty as yours. I'd like to know if our other friends also fell for the trick. That would at least be some consolation."

So they met with the other fish merchants and decided that the idiot had to be sent away. One of the merchants got his boat ready, and together they sailed out to the island and complained to the fisherman. The idiot had tricked them, and he as his lord and master had to pay for it.

The fisherman answered that he unfortunately couldn't assume responsibility because the idiot was just an idiot. And besides, the lobsters that the idiot sold to them were the ones that had been stolen from him. Against their will, the fish merchants were compelled to realize that they couldn't gain much by accusing the fisherman. But they remained firm in their demand that the idiot be sent away!

In the meantime the idiot had gone to the tavern, and for the first time in his life he sat down in the saloon. He drank so much that he became fully convinced that this was the best day in his entire life. And he became even more certain about this when a nice young little woman came over to him to help his drinking, even if he didn't notice that she took away the rest of his money when he became drunk. The tavern keeper, however, noticed this, and since an idiot without money was not a desirable guest in his saloon, he kicked the idiot out.

Now the idiot began to regret all the bad things that he had done, and while he tried to keep himself on his feet by leaning against a wall, he thought about the future of his soul and about all the good that existed in this and the next world. Just at that moment a young woman from the Salvation Army came by. She knew the idiot and saw that he was drunk.

"Do you regret deep down in your heart what you've done?" she asked, and then she invited him to drink a cup of coffee and to eat something with her in the Salvation Army headquarters. Soon he was sitting there and singing hymns in honor of God softly to himself, completely convinced that everything in the world was as it should be and that everything would get even better.

And when he had eaten fully to his heart's content and had drunk as much as he wanted, he thanked everyone, took his boat, and rowed back out to the island. But the closer he

came to the island, the more his good mood sank until he finally felt completely full of guilt.

The fisherman stood on the dock, and the idiot was afraid of what was waiting for him when he saw the fisherman. However, the fisherman invited him into his house, where he gave the idiot more coffee and cake, for he was a good man.

"I'm not angry at you for stealing my lobsters, my good friend," he said. "You took the fish merchants for a ride, and they're the ones who have often taken me for a ride. So, come, drink some more of this coffee!" ■

...it's better if we just play instead
with the blocks.

## 23  Hans and Grete: A Fairy Tale about Children Who Live in the Woods

I   Fruit Trees

It was a rainy November day when Hans and Grete were standing at the window and looking out into the garden. The garden circled the house and formed a clearing in the large woods in which they were living. Behind the house there was a steep incline, and that was where the fruit trees stood.

"Do you still remember when we sat in the cherry tree and ate thick red cherries?" Grete asked. She was always more lively than Hans.

"Yes," Hans responded. He usually didn't say much, but he still recalled how good the cherries tasted.

"And do you remember when we recently sat in the plum tree and ate cold yellow plums?"

"Yes," Hans responded.

"Weren't they good?"

"Frozen."

"Frozen is good."

"Yes."

Grete glanced from fruit tree to fruit tree and said, "Now there aren't even leaves on them anymore."

"But there are buds."

"Uh, how it's raining. But it will soon freeze, and then our fruit trees will look good."

"Very well," Hans responded, for he spoke very little.

"Then we'll go sleigh riding."

"If there's snow."

The rain kept coming down without relief.

"But in the spring, large white and fragrant blossoms will grow on all the branches."

"Yes," Hans responded.

However, the snow came first.

One evening, when it was dark and yet bright because the snow glistened, Hans went to the window while they were playing and looked out by chance.

"Grete," he said. "You must see this!"

Grete looked out. It was really quite wonderful! All around the trees the snow glittered a yellowish red and illuminated the fruit trees that stood like a colored sheaf in front of the dark pine woods, for only the tops of the trees were covered with snow. Silver threads floated above the fruit trees and wound themselves artificially into figures and moved softly like algae in the sea. A bright violet fog lifted itself from the ground, became thick, and turned into figures. All this became a glorious play onstage, and there were fine ladies with flowing gowns, dignified gentlemen in tuxedos, well-known national heroes and movie stars, and then even little Mickey Mouse.

"We've got to see this up close," Grete said, and she ran out over the veranda. Hans called her back and said, "You women have to see everything up close. Don't you remember how you drove away the deer that came out of the woods when you wanted to see it up close?"

But Grete wouldn't let herself be denied and said, "This isn't a deer. It's a miracle!"

"That's why it will burst more easily," said Hans, full of concern.

And really, no sooner was Grete through the door than it became completely dark. All the beautiful colors and all the fine ladies and gentlemen vanished. Then, naturally, Grete ran back to the window.

"You don't need to come back to the window," Hans said. "You don't think, do you, that the miracle was like a decal in the glass of the window?"

"But it should come back!"

"It's not going to return," Hans said. "Nothing comes back when people destroy it."

"If it doesn't return, then it wasn't worth anything."

"Wrong. People need miracles and ideals."

"If they burst so easily, then they're not worth anything."

"People cling to ideals and miracles so that they don't have to deal with their daily lives."

"But people can't do that with ideals and miracles. You see that ideals don't last. They shimmer and burst."

"Just let them calmly burst. They were nevertheless genuine as long as they glistened."

"I want ideals that last."

You'll never get that, Grete, because they wouldn't really be ideals anymore."

"What are they then?"

"Building blocks."

At that point Grete wanted to cry, but Hans fetched the building blocks and said, "It's better if we just play with the blocks instead!" ■

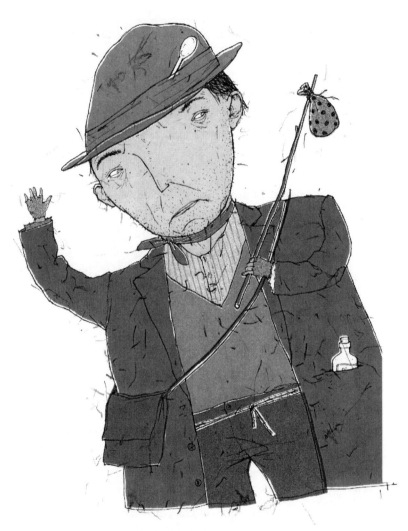

women want nothing
to do with me

## 24   The Fairy Tale about Happiness

Once upon a time there was an angel. Not what one generally calls an angel, rather a real angel who lived in heaven and wore wings. This angel had become involved in a quarrel with angels of the same merit and rank about the question of whether human beings were happy.

She was an extremely optimistic angel, and she tended to support the view that even if all human beings weren't happy, the question was still relevant, and one should also be able to find some practical cases to show whether people were happy. Her opponent in the argument maintained that it wasn't possible.

The result was a wager. They bet one apple of paradise, and our angel proposed that she herself would fly to earth to be convinced. So with a few soft beats of her wings she glided toward earth and landed safely on a country road that lay right between two villages. She hid her wings behind a nearby bush and toddled toward one of the villages.

There she encountered a beggar who was whistling while walking along the way.

"You really seem to be cheerful," the angel said to the beggar.

"I have no other choice, miss." he responded.

"So you're not happy? But you have it better than most people, wandering through the most beautiful regions without any exhausting work . . ."

"My work is among the most troubling that one can find," the beggar answered. "Everywhere I go, people use harsh words with me. They often set their dogs on me, and the women want nothing to do with me. You're really the only one who has spoken to me at all for years, but you seem to be an educated young lady. They don't exist here."

"Yes, but who do you think could really be happier than you?"

"Everyone is," said the beggar. "Especially the rich farmers who sit around the village because they live well at our expense."

"Thank you," the angel replied. "Then I want to visit one of these gentlemen."

So our angel went to one of the largest farms and asked to speak to the farmer.

"He's sleeping," the maid said.

"Naturally, I don't want to come at an inconvenient time," the angel responded.

Then the farmer's wife came and said, "He doesn't need to sleep the entire day like this during the harvest. Go and wake him, Marta. Tell him that a young lady from the city wants to speak to him. Then he'll be scared that one of his little girlfriends is visiting, and he'll come."

The farmer came rushing out, sleep in his eyes, and said brusquely, "What do you want, miss?"

"Only a small question. I want to know if you're happy."

The farmer grumpily fell into a chair and said, "Salvation Army or the Easter campaign?"

"What do you mean?"

"Okay, that's not it. Then you're collecting for some cause. How much?"

"Wrong guess. I'm asking in all seriousness whether you're happy."

"Oh, now I know. The young lady is doing research for a doctoral thesis. Please, take a seat. Do you smoke?"

"Thank you, no. Won't you answer my question?"

"All right, then I can only answer with no."

"But why not? You have a very beautiful life. You can sleep when you want. You can eat well—"

"I can pay taxes. No, young lady, nowadays people like me have a difficult time. If it's a good harvest, there's too much produce on the market so that you can't get high enough prices. If, however, the prices are good, then the harvest is bad. No, young lady, if you want a satisfying answer to your question, you must go to the city where people lead a more comfortable life. They don't have to stand behind the plow in all kinds of weather. They don't have to pay for insurance to protect them against hail. At least that's my point of view. They have all the reason to be happy."

The angel thanked him and flew to the city. ■

Cheerio.

## 25  Normal Insanity

Once upon a time there was a country, a very strange country, in which all the people were normal, mentally as well as physically, apart from a few exceptions.

In this country, to be abnormal or even crazy was regarded as the greatest of crimes and the greatest of disgraces, and all crimes in this respect were severely punished.

Even a single sign of insanity such as paying your taxes on time, giving details about your taxes without an exception, paying taxes in advance, paying debts, etc., would get you eight days of hard labor, and dementia praecox, two years. If you had paralysis, you would even be sentenced to forced labor for life. If you were a repeat offender, both your eyes would be covered and your ears stuffed with cotton in order to make the forced labor more difficult.

This was how hard any attempt to be crazy was punished. Cheerio.

One time the "Women's Society for Prevention of Insanity by Setting an Example" held its general meeting. The president began by presenting the annual report because annual

reports are the purpose and goal of societies. She reported that the presidency had changed, and the new presidency had become even stricter in persecuting any kind of insane behavior, but despite these actions, the number of new cases of insanity had steadily increased.

The second speaker was called Mrs. Iss. She asserted that, in contrast to this unpleasant increase of the external cases of insanity, the insanity within the organization of the "Women's Society for Prevention of Insanity by Setting an Example" had understandably decreased rather than having increased. The exemplary champion fighters of healthy human intelligence had demonstrated little tendency to fall victim themselves to unhealthy insanity, and this little tendency was enormously reinforced by the constant championing of the true model of healthy normal humanity, even if it meant that the gap between the normal person and the insane person increased by doing this.

Then she went far afield and said that the normality of people was something normal. On the other hand, if one were critical, one could call the reinforcement of this normality somewhat abnormal. The uncritical person, however, like most of the members of the "Women's Society for the Prevention of Insanity by Setting an Example," must recognize the increased normalcy as the thorough and completely new normality whereby the old normality that had not increased would be stamped by itself as abnormal and thereby marked as insane.

After Mrs. Iss made her remarks, thirty members asked to speak all at the same time, and they began speaking immediately and causing so much confusion that the president, Mrs. Hau, had to pound on the lectern until there was silence again.

Thereupon Mrs. Hau gave Miss Eulein permission to speak.

Miss Eulein sharply rejected the assertion made by Mrs. Iss that most of the members of the "Women's Society for the Prevention of Insanity by Setting an Example" were uncritical people. She tried to support her argument by pointing out that, to a certain degree, the proof was brought by Mrs. Iss that the society had used razor-sharp criticism on itself. Then she apologized that she unfortunately felt compelled to give Mrs. Iss a good bashing on her noggin.

At this point Mrs. Kau interrupted her and asked, "What, may I ask, is Mrs. Iss's noggin?"

"Her noggin," said Mr. Kerr, "is the intelligence that has shot over her head." ■

are you feeling
happy brother?

## 26   What Is Happiness?

Who can say what happiness is?

This story took place long ago. It was during the time when there was still a heaven in which the souls of good people promenaded. They were dressed in white and had long wings and flew, or rather, floated, when they used their wings, to fly from flower to flower. These flights were not hampered by loads of bombs, for the angels came not as enemies but as friends. Their souls were all headed in the same direction, and their goal was happiness.

They often flew to the edge of a large pool of water that was populated by white swans and discussed the topic of happiness. As they sat on the edge of the marble pool, they let their feet drop into the water to cool them while the goldfish stroked their feet. A brightly lit fountain stood in the middle of the pool and continually changed into the most beautiful colors. There was a row of wind harps set up around the pool that blew hymns into the air.

Suddenly an angel dressed in pink stood up on her tiptoes and cried, "There's no such thing as happiness!"

In response three other angels turned crimson and answered in unison, "Happiness exists in the souls of people, and people have as much happiness as they can carry with them."

And once again the pink angel announced, "There is no such thing as happiness!"

Now another angel suddenly became bright green, because green is the color of hope, and he flew into the air and said, "I'm going to fly to earth, and I'll ascertain whether there is happiness. I think there is happiness, and I'm going to search for it. When I've found it, I'll tell all of you angels where it is, just where happiness is."

With three or four soft beats of his wings, the green angel glided down from the edge of heaven and approached the planet earth. He arrived just as a world war was raging. Thousands of planes with ten motors hovered in the air just like angels. But while the green angel threw flowers down onto the earth, the planes dropped high explosive bombs and fire bombs. When the pilots of the planes saw the angel, they opened fire with machine guns. But all the fire and shots bounced off his green outfit.

When the angel saw the planes, he thought to himself, "It's strange that those angels use motors to fly about on earth!"

Meanwhile, the motors of the planes hummed all together to form a concert in which the exploding bombs became the clashing of the cymbals and the shooting of the machine guns became the drum rolls. Large cities burned and dis-

integrated into charred stones. Flames and smoke rose toward heaven and wrapped the angel with bitter clouds. Gas and steam stunned him, and he landed between a hundred thousand dead and dying soldiers, whom the war had just mowed down.

A blind soldier, whose two legs had just been shot off, stretched his arms high in the air in pain, and he began to sing a hymn backward. The angel, who was nearby, asked him, "Are you feeling happy, brother?"

And the soldier howled and screamed, "I'm just happy to be able to die right now, but I'm not happy. Search for happiness behind the front. My comrades in the communications zone, they're the happy ones."

With these words, the blind soldier without legs passed away.

The angel looked around him and saw a great deal of misery. The burned, poisoned, and crippled soldiers crouched around him and waited for the shots that would bring their suffering to an end.

"We curse that man who brought this war upon us!" a shrill voice cried out.

"There can't be such a thing as a good God," a second voice shouted. "If so, how could he look at all this misery?"

"It's God who has brought this misery to the people in order to make them happy!" the field chaplain announced with a broken voice.

"You're right," the angel said to him, "but you can't call misery happiness. Where is happiness?"

However, the field chaplain had died in the meantime and couldn't answer anymore. And a hundred, a thousand, and hundreds of thousands more soldiers died all around, or they were crippled. So it became clear to the angel that it would be difficult to find happiness here. Therefore, he set out for the communications zone and went by mass graves, destroyed churches, churned-up cemeteries, burning hospitals and tanks that were rushing to the front in order to annihilate the enemy army with flame guns.

"Still, I'm sure there's happiness," said the green angel, who continued his wanderings. When he arrived in the communications zone, he saw a large parade. The well-dressed soldiers marched by their commanding officers with clattering steps while the officers looked critically and unfavorably for the tiniest mistakes in the formation of the parade. Commands thundered, legs swung, looks raged, and the judgment of the soldiers was pressed between blotting paper. Each one of the commanding officers was master and slave at the same time. The soldiers were slaves, slaves of an idea that had been crystallized in the word "fatherland." The green angel attempted to march with them with a light bobbing of his wings, but he couldn't march in time to the regular and steady beat of the columns without enough air, and so he thought they must probably be happy that they could march so beautifully. He asked the soldier nearest to him whether he was happy.

"Shut your mouth!" the soldier squeezed some words between his teeth.

The angel didn't grasp why he should shut his mouth and continued to ask. The soldier didn't answer any more. Suddenly the general cried out to all the soldiers, "Halt!"

His voice thundered, and all at once the soldiers stood like lampposts.

"Who's that idiotic woman marching in our columns?" the general asked.

Everyone turned to look at the angel, and the major said, "Step forward, wench!"

Then the captain yelled, "Lower your wings!"

However, the angel didn't know about discipline and lifted himself lightly into the air and hovered right over the heads of the soldiers and the general in the direction of the hinterland. Consequently, the general degraded the major; the major, the captain; the captain, the lieutenant; and so on. The sergeant sentenced the soldiers to stand twenty-four hours on one leg as punishment because the angel had tried to march with them in the parade. Meanwhile the angel thought, "I don't think that this is the place to look for happiness." ■

and he could smell
how
they were intended

## 27 The Man with the Glass Nose

Once upon a time there was a man who had a nose made of glass. The reason he didn't notice it and why other people didn't know was thanks to the fact that this glass nose was so completely covered with skin, it looked like a normal nose, and it functioned like a normal nose when he had a cold and in other conditions of life. At the same time it was a very exceptional and unusual nose, and as time went by, one noticed that a small glass tip showed itself on the skin of the nose. There are people whose hair begins to fall out when they become more mature, older, and smarter. First it happens in the middle of the head. A small hairless spot shows. Then the spot becomes shiny and larger until something we call baldness develops. This was also the case with this man's nose. In particular it was the skin covering the nose that gradually became thinner and receded more and more until finally the entire nose became glass and glistened like a crystal.

It didn't look stupid. A nose radiated and twinkled in the middle of his face, and it could reflect the most improbable lights and colors and allowed objects to shine through in fragments and in a colorful mixture far away in the green distance. Indeed, everyone wished to have such a beautiful, shining, sparkling, and glowing nose as this man had.

One day this man noticed that he could smell transparent things. That was very unusual. Just think if, for example, you could smell my thoughts or the thoughts of another person! How embarrassing it would be for us! If, for instance, I could smell what you think about this grotesque matter, how embarrassing! All the members of the secret police would wish for such a glass nose. Or, don't you think so?

At the beginning, when that man noticed his new abilities, he started to sniff shyly into the world like a young girl. And when it stank too much, he pinched his glass nose shut. People with glass noses know that people often don't smell very nice, even those who think that they smell very nice. And it is very seldom that even the best-smelling people ever match the aroma of a rose. What young girl would ever say in polite society, "It stinks here!" And in this same regard, the man with the glass nose would modestly swallow down a great sum of the bad smells that came storming at him. As compensation for his suffering, he also had the same triumphs that a young girl might often celebrate because of her beauty. Nobody would ever say to a fat bald man, "Oh my, it's just wonderful how your bald head is shining once again!" On the other hand, one likes to say to young girls, "You look vibrant today. Your dark eyelashes, your flaming lips, your glistening green eyes, the red glow of your cheeks—how can I find the right words to describe everything?"

And so people used to say to this man, "Oh my, Erich, how wonderful your iridescent Cyranian nose is shining again!* But your nose is more pure than Cyrano! You know

that whoever is called Cyrano must be able to smell like a rose. Your diamond nose spreads like a rainbow. Your nose collects all the splendor of the rainbow and all the light of the sun and spends everything extravagantly on all the people."

Hearing all this, Erich used to become red, and the crystal of his green nose would grow enormously in this red glow. And now try to imagine yourself psychologically in the exact situation of a young girl. If a lover makes too many compliments, she gradually finds him tasteless, and the lover soon becomes loveless. At first she is perhaps still polite to him and says, "What do you think of Beethoven?" When, however, he becomes unbearable, she snarls and says, "You smell like cheese!"

This is also what happened to Erich. The compliments became too much for him, especially because they stunk, and he could smell how they were intended. For instance, when someone swooned about the diamond fire of his clear crystal nose, Erich could smell that he meant, "This conceited drip! If I myself had such a dirty icicle dripping from my face, I'd hide my head in shame." Just to think something like this is outrageous. A bald-headed fatso would never stand for something like that. He would say: "You stupid fool with your greasy lice-ridden wig, just leave me alone! Any ass can think in one short minute more than you have ever thought in your entire life." ∎

and they both
devoured the woman

## 28  Once upon a Time There Was a Tiny Mouse

Once upon a time there was a tiny mouse. It heard that the woman who ruled the house had set the large cat to pursue the mouse's siblings. The poor little mice sought shelter in all the corners of the house, but when one of them tried to find a better hiding place, the cat ate it and continued to eat one after the other. Soon it was the tiny smart mouse's turn, and it remained in its hiding place until the cat fell asleep.

Now even in the breast of the tiniest mouse there are great feelings, at least for a while. And so the tiny mouse thought about revenge. All of a sudden the mouse had an idea: a growth serum. It knew where the woman stored the large bottle and drank a big swig of the serum.

When the cat awoke the next morning, a mouse was standing there, and it was much larger than itself. The cat ran away out of fright, but when the woman saw this, she caught the cat and said, "You're too small if you run away from mice," and she gave him an injection of the growth serum. In the evening the cat was as strong as a lion and played with the gigantic mouse. So the woman was happy and said, "Good cat, now go and eat your mouse!"

However, the cat thought, "Who do you think you are, woman, giving me orders?! After all, I'm a lion!"

And with these words it sprung upon the woman and tore her apart. Then the cat sat down to have a meal with the gigantic mouse, and they both devoured the woman, for they had become very hungry from all that enormous growing. ■

**Tales Written in English** ■

From 1941 until his death in 1948, Schwitters made a concerted effort to speak and write only in English as a reaction against the "nazification" of Germany. Though he became fluent in English, his writing was often awkward and ungrammatical. Nevertheless, the unpolished nature of his English tales seems appropriate for his Merz concept. Schwitters always strived to be asymmetrical. In discussing her collaboration on the children's books with Schwitters, Kate Steinitz reported, "Schwitters was a good teacher, and he made things seem very simple. One had only to think in terms of horizontals and verticals: The printed page will gain both tension and equilibrium by an asymmetrical arrangement. We'll typeset the text as a block. Thus we'll get beautiful square white spaces left over, or rectangular empty spaces. That is our new modern principle. Formerly title pages were all centered. The result was symmetry, of course, but not interesting design."

"Why are you so against poor old symmetry?" I asked. "The human body is symmetrical."

"Yes," he said, "but only externally. At the Science Exhibition there was a man made out of glass. One could see that everything inside was asymmetrical. The organs were a bit crowded, but functional. Probably we're all asymmetrically arranged inside. Now look how dull such an old-fashioned, symmetrical page looks! Each line has its center right in the middle of the page, and the lines below (one longer, one shorter) never leave a beautiful white negative space, but only a jittery, irregular profile. Now, we'll compose this children's book to show the beauty of white squares and rectangles balanced against clean blocks of type. You'll see. Each deviation from the rule will look terrific. For example, your drawings" (*Kurt Schwitters: A Portrait from Life*, 36–37).

Whether it was in English or in German, Schwitters's writing always deviated from the norm.

he painted
round figures round
in the air

## 29 The Flat and the Round Painter

Once upon a time there was a painter-chap who painted his paintings in the air—not plain flat figures with flat paint brushes on flat canvas, which were painted  so flat that they really looked flat and plain—but he painted round figures round in the air.

So he painted a queen. She had an enormous velvet skirt on her legs, and a crown on her head, and a shock of hair under the crown, which looked like a cake. So beautifully it was done. And her graceful arms with slim fingers and the big brilliant rings on her fingers moved, as the fingers of a queen used to move.

Then the wind came and blew Her Majesty the Queen away, and the painter observed this display with anxious eyes. The queen wobbled and bubbled in the air, and swayed and waved just as the air under her waved and swayed. Suddenly she grew quite thick round the middle, blew herself up, burst, and fell in two pieces. The skirt with the legs by itself, and the bosom with the crown by themselves. When

the painter-chap saw this, he got very serious, and painted in a great hurry, a page-boy in the air. Not a flat page-boy with flat paintbrush on flat canvas who was painted so flat that he really looked flat and plain, but he painted a round page-boy round in the air. He had a tightly fitting dress on his thin legs, and big longing eyes under his page-crop, and his fingers were as thin as graceful matches.

Then the wind came and blew the page-boy in the direction of the queen who had burst. He trembled and scrambled in the air, and he shivered and schwittered, like the air under him schwittered and shivered. And his eyes and fingers were longing to put the queen in order again. Therefore, he kicked his little legs in the air so that he might get ahead a bit more quickly, and he slipped several times and fell, for it was cold, and the air was slippery with ice.

Suddenly as he reached the parted parts of the departing queen, he grew quite thick round the middle, blew himself up, burst, and fell in two pieces.

The tightly fitting dress with the legs by itself, and the longing eyes with the fingers by themselves, for he was quite near his adored queen.

Now, his legs and fingers had still kept the direction of the fast chase. And thus his legs put themselves under the fat bosom of the queen, and the longing eyes with the matchfingers put themselves on top of her enormous skirt, and they grew on there. But it looked so horrible that the painter, full of fright, decided to paint himself in the air in order to re-

arrange them in the right order; for his brush was not long enough.

He did not paint himself flat with a flat brush on flat canvas like the other painters who used to paint plain, flat figures—as you already know—on flat canvases, which were painted  so flat that they really looked flat and plain, but he painted himself with his round brush round in the air. Then the wind came and blew him in the direction of the two figures. He kicked his legs in the air as much as he could, because he wanted to get to the place of the accident quickly, he slipped several times and fell, because still nobody had strewn ashes on the air.

Suddenly as he reached the two figures, he grew quite round in the middle, blew himself up, and burst not in two pieces, but in so many small parts that he could no longer be seen, and with him burst the ability of the painters to paint round figures round in the air with round brushes.

Therefore, painters now paint plain, flat figures with flat brushes on canvas. ■

with this letter in
your pocket we will
pass the car in front

## 30  London: A Fairy Tale

Once upon a time I was sleeping in my house at 39 West-moreland Road, when I suddenly awoke, and there stood in my little room a fine lady. I don't know whether it was per-haps my mother, or the girl I love, or even a real fairy. She invited me with a movement of her hand to follow her, and took me in her excellent car to the east of London.

But there was not, as I knew from before the domicile of poor people, with a lot of dirty children on the streets, there was not the Commercial road with its tremendous traffic, and there were not all the jews with their shoppingcars. All had disappeared, and there was a wonderful park, as nice as only nature can make it. In a valley she stopped and invited me for a walk into the wood.

All people walking there were happy. Their singing mixed harmonically with the classic arias of the birds. They didn't speak more than was absolutely necessary, and what they said was really wonderful.

We walked between green meadows and forests to a warm pond and happy people bathed in the clean green water, without whistling any songs. They got clean in body and soul, although the water didn't get dirty from the bath-ing people. Even when a company of soldiers stopped there

for bathing in the pond, you couldn't see a bit of dirt and couldn't hear any noise at all.

I asked the fairy whether I was allowed to take a bath myself, and she allowed me to do it tomorrow, because we still had far to go, as I had to be back at Barnes before sunrise.

We went back to the fairy's car and drove up a hill, and it was in the direction of Earl's Court.

Suddenly there drove in front of us a big car, carrying one whole big house wall with all windows, an entrance door, pictures on the walls inside, and you saw dead persons through the curtains, sitting on tables, looking at one another, and being very serious.

We couldn't possibly pass this car, because the wall took the whole road. Suddenly I remarked lying on the road a letter. The fairy stopped her car, and I took the letter.

"What shall I do with this letter," I asked the fairy, "it is written to somebody's dead brother."

"Put it into your pocket," she answered, "with this letter in your pocket we will pass the car before us."

And really, when I had the letter in my pocket, the car in front of us turned the wall into its own direction, and you could see, that it was flat, and there were no dead persons behind it.

We quickly passed this unusual obstacle and entered Earl's Court. That was a very pretty part of London. The wonderful green hills had big windows, through which you could see into their interior. There you saw thousands of rooms, all of them inhabited by different animals. There were always two

animals of the same kind in one room, and they looked very happy. Between the rooms of the different animals there were no doors, but only windows, so that the lions could speak to the goats, but couldn't visit them. Most of the animals were horses of course.

At Hammersmith stopped the car, and my fairy said, I now had to walk alone by myself to Barnes. I passed a group of visitors of the London horses with their guide.

Suddenly a young man stopped, and with him his parents. He said to his father: "Look at that!" And went with his hand into my pocket.

"Do you want any special thing?" I asked.

"I do," answered he, "I want this letter," and he showed me the letter which I had found, it was from his father written to his dead brother.

The father became interested in this letter, and the son passed it on to him. Then the father made some notes from the letter. Therefore I asked him to take the letter and keep it as long as he needed it. Finally we made the appointment that he would phone Riverside 1698 and speak things over with me. I invited him to come and see my abstract pictures on this occasion. ■

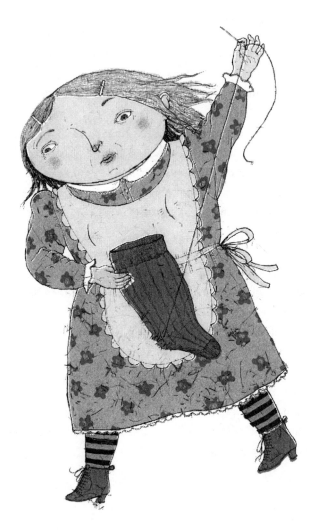

"...I come with you on condition
that I may go on darning your socks."

## 31  The Flying Fish

The story I am going to tell you is rather a sad one. But there are sad ones among the stories, and why should I not write a sad one, as they are written nevertheless by others.

I know, once upon a time there lived a fish in the sea. There live perhaps millions of fish in the sea, and among those millions of fishes there lived also one, this fish I am speaking about. He was a darling fish, and did not like other fishes. Naturally, he disgusted all of them. There was always the same sludder, and he hated nothing more than that. He admired human beings, although he knew the down part of them, as they put their heads out of water when they bathed.

They were so calm and so quiet, and our fish thought that they lived together with the Gods somewhere in the world.

The favourite place of our fish was just under the surface of the water, which was the underface of the air as well, and he looked through this underface, in order to look after the human beings in the air. That they might also live on islands, as, for example, the British people do, was impossible for him to think, because he did not know that there existed islands at all.

He never saw human beings in the air, therefore he thought they might be invisible up there, like Gods. Often he saw birds flying in the air, and he asked himself, whether he could not fly as well as they did. He knew, that birds could not swim under water, because they didn't try it. And when they would try to fly under water, that would not be possible to do. He did not try either to swim in the air. He tried to fly. Of course he could, when he only would, could not he swim in the water? And so he decided to fly up into the air, to see the human beings. And in one unregarded moment he jumped out of the corner of a big wave and was in the air. Soon he came over the first difficulties and flew first under the clouds, then above the clouds. There he was quite near the sun, but could not see any human beings at all.

At that time there lived at the seaside Mr. Smith with his wife, Mrs. Smithis. Mr. Smith looked out the window into the sunshine, while Mrs. Smithis darned her husband's socks.

"It is a nice day today," said Mr. Smith to his wife.

"It is a nice day today," repeated Mrs. Smithis.

"Lovely," said Mr. Smith, and his wife repeated: "Lovely."

"I have got an idea," said Mr. Smith, "should we not have a nice trip with my newly-bought aeroplane above the sea?"

"What is the weather like darling?" asked Mrs. Smithis.

"Didn't I say that it is a nice day today?"

"You did, but does that mean anything at all, when you say: it is a nice day today?"

"Of course, sometimes it does, and I am going to fetch my plane."

"Never mind, I come with you under the condition that I may go on darning your socks."

And soon Mr. Smith and Mrs. Smithis sat in their new aeroplane and flew into the air, first under the clouds, after a while above the clouds, and suddenly Mr. Smith asked: "Do you see what I see?"

"No, darling," replied his wife, "I am darning your socks."

"I see a fish," said Mr. Smith.

"You should shoot the fish."

"Don't be silly, I haven't got a rifle; but don't you know what this fish means?"

"Perhaps luck?"

"Luck? No! We are under water, that is what it means."

"We are under water? O dear, dear!"

"And you know that human beings cannot live under water for a long time?"

"Why, darling?"

"Idiot, they cannot breathe water without dying."

"O dear, dear, what shall we do, what shall we do?"

"I have an idea," said Mr. Smith. "Look at the surface of the water. That is not a surface, that is the underface of the air. You only see the clouds through the underface. When you mean to see down, you actually see up, because our new aeroplane flies upside down. I must turn it downside up, then we come out of the water again, into the air, and when you look down afterwards, you really look down and not up."

And suddenly he turned the newly-bought aeroplane, and soon it went with a clash through the underface of the air. And—burst into pieces.

And Mr. and Mrs. Smith sank into the water and drowned. I told you before that I was going to tell you a sad story. Didn't I?

But now you are surely glad, that the fish lives. You are in a way right, the fish lived still, when Mr. and Mrs. Smith died. He flew in the air and enjoyed life.

When he saw the aeroplane coming, he thought first, that there might be Gods in it. He came quite near the window and saw through it. How glad he was, when he saw two human beings at once, and how beautifully they were dressed! Not only round the hips, but all over. He admired these fully dressed human beings.

Suddenly he saw that the newly-bought aeroplane rushed to drop into the sea. He knew that human beings cannot live under water, and he had such a good heart that he decided to

help them as much as he could. He didn't know himself how. Therefore he rushed to jump down into the sea and arrived there shortly after the newly-bought aeroplane with the two fully dressed human beings crashed.

When the other fishes saw him coming back into the sea, they surrounded him, and shouted, and the fish got furious and bit all of them.

But as there were so many, they killed him.

I told you before that it would be a very sad story. ∎

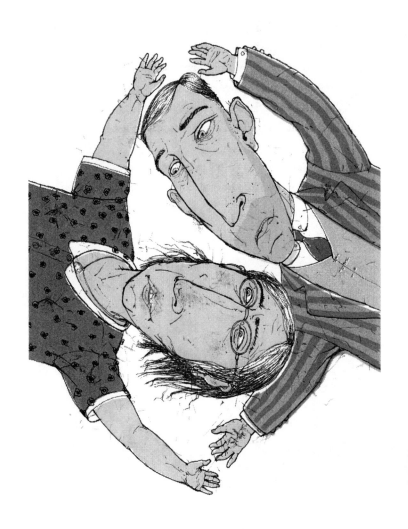

It was a beautiful place
and a lovely evening

## 32    Twopenny Novel about an Ugly Girl

Once upon a time there lived a man. He was not a handsome man, but all the girls who knew him fell in love with him. He didn't love any of the girls—you couldn't say that. But he liked to flirt with the most beautiful of them all, to make one jealous of the other, until finally he got tired of flirting too.

But as he had flirted with so many girls, and they would not give him up, he had to flee from the town in which he had lived for so many years.

Therefore he decided to travel, once or twice around the world, into other countries—with girls that he didn't know, and that he didn't need to care for, and one day he found himself standing on the deck of the big boat, looking forward over the green waves of sea, into a better future—without loving and without flirting with girls.

But what was that? Just on his right side he heard whispering, and when he looked here to enquire what it was, he saw a rather beautiful girl flirting with a man. It was disgusting! He went away on the other side of the big passenger-boat, where he could regard the sun-set over the sea, with red and green clouds. On this occasion he passed a bench, standing in the shadow, and what do you think he was seeing in this shadow? He saw a girl kissing a man with her arms around his neck. It was awful! Therefore he went straight to the railing and stood leaning against it, so that he could only see the big waves of the sea.

Suddenly he felt that a girl was standing by his side, leaning on the railing like him. He didn't dare to look, because he was afraid of being able to see a girl he would fall in love with.

"It is a lovely evening, isn't it?" said the girl.

"It is," he replied, looking away from her. But then he thought it couldn't be wrong, looking at her with one eye, and as he saw that she was ugly, he looked with both of his eyes.

Now he had found in his very age, away from love and flirting, a girl he could speak with—without danger, because he would never flirt with an ugly girl. Therefore he said to her: "My Lady, look once around you on this boat. Is it not disgusting to see so many people without moral, flirting and flirting," and he thought that she would answer, "it is."

But she answered, asking him: "Did you ever flirt in your life? I like it."

"Yes, I did," he said, "but I don't like it at all."

Then they stood a long time together without speaking a word. She thought: "This gentleman is a fish without warm blood" and he thought: "This lady is ugly, but she behaves the same as the beautiful ladies. She wants to flirt and to be happy. I could make her happy by flirting with her, but I wouldn't, would I? I could if I would, and it wouldn't hurt me, because she is ugly, and I have nothing to do on this voyage, and she could help me hide from the beautiful girls with whom I could fall in love."

The next morning the boat landed on an island. The travelers went on land to see the beautiful town. He stood on the deck, not knowing whether to go out or not, and by his side, suddenly appeared the ugly girl, and said: "Of course, we don't go into the town. We shall go beyond that hill there. It's nice to be alone."

"I didn't suggest going on land," he said.

But they went together beyond the hill, and it was a beautiful place and a lovely evening. ■

**Appendix: German Version of "Die Scheuche"** ■

# DIE SCHEUCHE

## MÄRCHEN

TYPOGRAFISCH GESTALTET VON
KURT SCHWITTERS KATE STEINITZ TH. VAN DOESBURG

# DIE SCHEUCHE X

**Es war einmal ne Vogelscheuche**

**die hatte einen Hut-Schapo**

**und einen Frack**

F RACK

**und Stock**

**und einen ACH**

so schönen Spitzenschal

# DA kam Monsieur Mosjö

le coq

der Hahn

und hickte an dem Stock

und machte Hick und Hack

und    hic    haec    hoc

und hickte an dem Stock

**D A** kam das Hühnchen an

P→u,

DA sprach M^OSJ⊙ LE CO^Q zu | Hut und

Rock und Stock und zu dem **ACH** so schönen
Spitzenschal **PFUI ALTE**R Mann du bist ja
eine Scheuche Hick Hack und hic haec hoc

**UND** kamen **ALL** die Hühnerchen an
und forchten nicht den Stock und hackten

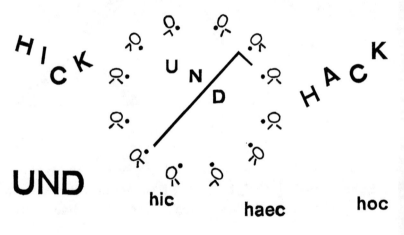

**UND**

hic      haec      hoc

**NUN** kam der Bauersmann
und SAH mosjö le coq
und seine Hühnerchen

die machten Hick und Hack
und hic haec hoc und pickten
ALLE Körnerchen auf

und forchten **NICHT**
**DEN STOCK**

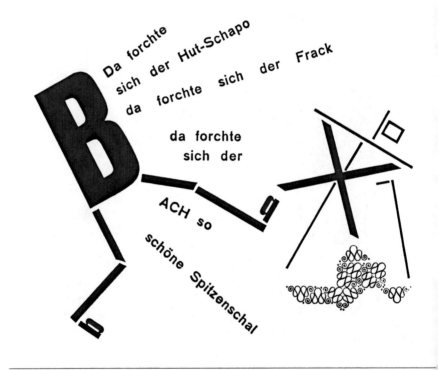

Da forchte
sich der Hut-Schapo
da forchte sich der Frack

da forchte
sich der

ACH so

schöne Spitzenschal

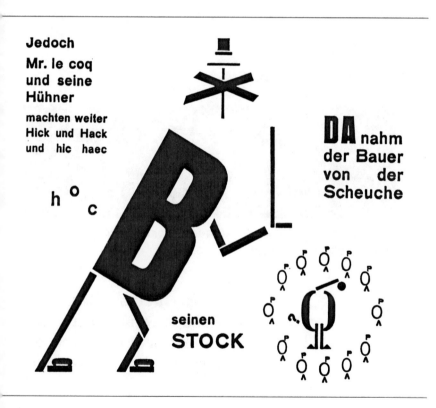

Jedoch
**Mr. le coq
und seine
Hühner**

machten weiter
Hick und Hack
und hic haec

h ° c

**B**

**DA** nahm
der Bauer
von     der
Scheuche

seinen
**STOCK**

mit einem
Male
ward es
dustre Nacht

und keiner sah und keiner hickte hic haec hoc
und Hick und Hack . . .

# DA freute sich der
Hut-Schapo und freute sich
der Rock und freute sich der
ACH so schöne Spitzenschal

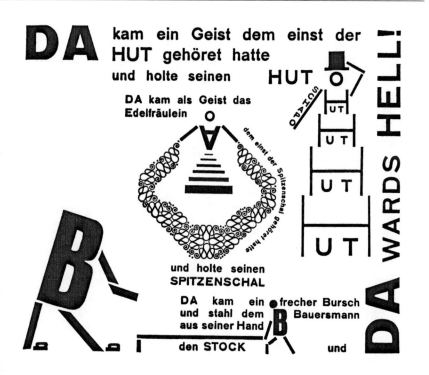

DA kam ein Geist dem einst der HUT gehöret hatte und holte seinen

DA kam als Geist das Edelfräulein

dem einst der Spitzenschal gehöret hatte

und holte seinen SPITZENSCHAL

DA kam ein frecher Bursch Bauersmann und stahl dem aus seiner Hand den STOCK und

HUT

STOCK

UT

UT

UT

UT

DA WARDS HELL!

# Notes

The most important collection of Kurt Schwitters's manuscripts can be found in the Kurt Schwitters Archive in Oslo, Norway. The dates following the titles indicate the year when the tale was written.

KSA—Kurt Schwitters Archive, Oslo

GMs. —Manuscript in Gabelsberg shorthand

HMs. —Handwritten manuscript

MMs. —Typewritten manuscript

## Tales Written in German

### The Swineherd and the Great, Illustrious Writer—Der Schweinehirt und der Dichterfürst (1925)

Published in the *Hannoverscher Kurier* (December 16, 1926): 2.

The term *Dichterfürst* is difficult to translate into English. Literally, it means "prince of poets." *Dichter* in German simply means "poet," but it can also indicate a writer who is extremely talented and superior to "ordinary" writers, or *Schriftsteller*. Schwitters was mocking the tradition of court poets and also contemporary writers who had no idea how to represent common people and satisfy their desires. As in all his fairy tales, happiness remains elusive.

### Lucky Hans—Der glückliche Hans (1925)

Published in the *Hannoverscher Kurier* (October 17, 1925): 2.

This tale plays on the double meaning of *glücklich*, which can mean "happy" and "lucky." It is a social commentary about unemployment and dire conditions in the early 1920s. In traditional fairy tales, animals are often helpers and give the protagonist a gift so

that he can accomplish a task. In this tale, Schwitters mocks the role of the animal by having the rabbit literally give Hans the skin off its back. In the German folktale tradition, Hans is frequently a bumbling blockhead. Sometimes he lands on his feet, but more often he causes some kind of disaster.

### Happiness—Das Glück (1925)

Published in the *Hannoverscher Kurier* (November 25, 1925): 2.

This mock fairy tale is a tongue-in-cheek narrative that transforms the fairy godmother of conventional fairy tales into a sarcastic gypsy. Schwitters was obsessed by the theme of happiness and believed that only by not seeking it might, one become content. Life would always remain unfinished.

### The Little Clock Spirit and the Lovers—Uhrgeistchen und Liebespaar (1925)

Number 126, MMs., KSA

As in his famous poem "To Anna Bloom," this tale parodies conventional love and romanticism.

### The Proud Young Woman—Das stolze Mädchen (1925)

Number 127, MMs., KSA

This tale recalls the famous "King Thrushbeard" tale collected by the Brothers Grimm. The plot of a woman punished for her pride can be traced as far back as the medieval *1001 Arabian Nights*. However, in most of the "King Thrushbeard" tales the princess eventually marries the king who has humiliated her. Schwitters's ending is not as rosy.

**An Old Fairy Tale**—Altes Märchen (1925)

Published in the *Braunschweiger Neueste Nachrichten* (June 30, 1926).

Like the previous tale, this is a bitter and ironic reversal of the traditional fairy tale that always rewards the hero's good actions and gives him a second chance.

**The Scarecrow**—Die Scheuche (1925)

Written and published in collaboration with Kate Steinitz and Theo van Doesburg (Hannover: Aposs, 1925). Schwitters wrote the tale and then collaborated with Steinitz, van Doesburg, and the typesetter Paul Vogt to create the letters, forms, and spacing. Intended for children, the book was so unusual that it never received the attention it deserved. The influences of futurism and constructivism, as well as of De Stijl (which was van Doesburg's contribution), are evident.

The following is my English translation, which Barrie Tullett designed typographically in keeping with the layout conceived by Schwitters, Steinitz, and van Doesburg. Please see the appendix for the original German. Aposs, which stood for Active, Paradox, Oppose Sentimentality, and Sensitive, was the name of the publishing house founded by Steinitz and Schwitters, who self-published the book. The venture lasted two years.

The Scarecrow

Once upon a time there was a scarecrow
that had a top hat, a tux, and a cane,
and oh, such a lovely lace scarf!

Then came Monsieur Le Coq,
Cock-a-doodle-do,
who pecked at the cane, pick peck,
and pick peck pock,
and pecked at the cane,
and he didn't have a cane and oh, such a lovely lace scarf.

Then the hen arrived,
and Monsieur Le Coq said
to the hat, the tux, and the cane
and the oh, such a lovely lace scarf,
"Phooey, old man, you're a measly scarecrow.
Pick peck and pick peck pock."

Then all the hens arrived
and showed no fear of the cane,
and they pecked, pick and peck, and peck pick pock.
Now the top hat got mad, and the tux as well.
And the cane got mad and the oh, such a lovely lace scarf
    as well.

Then the farmer arrived
and saw Monsieur Le Coq and his hens as well,
pecking and picking, and pick peck pock.
And they pecked up all the grain
and showed no fear of the cane.

So the farmer said, "Phooey, you scarecrow!
You're no scarecrow. I'll soon make a corpse of you."

So the top hat got scared,
and the tux as well.

Then the oh, such a lovely lace scarf as well.
But Monsier Le Coq and his hens
kept pecking and picking, pick peck pock.

Then the farmer grabbed the scarecrow's cane,
and suddenly it became so dismally dark.
Nobody saw and nobody pecked,
pick peck and pock and pock and peck. . .

Now the top hat was glad
and the tux as well
and the oh, so lovely lace scarf as well.
Then a ghost appeared who had owned the hat,
and he grabbed the hat just like that.
Then a lady arrived, a ghost as well,
who had once owned the lovely scarf of lace,
and now she grabbed the scarf as well.

Last to come was a big bold lad
who stole the cane from the farmer's hand,
and then the day turned very bright!

### He—Er (1927)

Written in 1923 and rewritten and published in *Der Sturm* 18.4/5
(April/May 1927): 50–62.

This tale is a clear critique of the inflation that the German govern-
ment could not control between 1919 and 1924. In addition, Schwit-
ters makes the military look ridiculous. The reference to Auguste
Bolte is to a story that he wrote in 1923 about a preposterous woman,
Auguste Bolte, who runs after something and does not know why
she is doing so. In this regard, she represents the spirit of the times.

In Schwitters's tale the officers, the general, and the king are similar to Auguste Bolte.

### Fish and Man—Fisch und Mensch (1927)

Date: March 18, 1927

Number 194, MMs., KSA

Dedicated to Hans Richter

Richter was an important Dadaist with whom Schwitters was friendly. The tale captures important strains of Dadaist art.

### The Squinting Doll—Die schielende Puppe (1927)

Number 214, MMs., KSA

Sasha Leontiev, a Russian writer and dancer, met Schwitters in Hannover, where he performed before a sold-out house. Leontiev published poetry and fairy tales that he shared with Schwitters.

### Three Suitcases—Drei Koffer (1927)

Leontiev also told this tale to Schwitters. It bears the marks of Hans Christian Andersen, who often anthropomorphized objects, wrote ironically about romantic relationships, and exposed the pretensions of uppity people like the elderly lady in this tale.

### Fairy Tale—Märchen (1928)

Date: Naples, March 31, 1928

GMs., KSA

Schwitters wrote this tale while he was in Naples, Italy, and he may have been influenced by the Neapolitan oral tradition. The trip to southern Italy in the spring of 1928 led to a rebirth of Schwitters's creativity.

**A King without People**—König ohne Volk (1932)

Written with Maryan Rawicz

GMs., KSA

This tale is one of Schwitters's best nonsense narratives.

**The Story about the Good Man**—Die Fabel vom guten Menschen (1933)

Date: June 10, 1933

MMs., KSA

Schwitters combined elements of the fairy tale and the fable to convey a bitter moral about the good Samaritan.

**Happy Country**—Glückliches Land (1933)

Date: July 2, 1933

MMs., KSA

The first version of this tale was titled "Altes Land" ("Old Land"), and Schwitters was prompted to write it by his son, Ernst. The reference to Hitler and the Third Reich is clear.

**The Story about the Rabbit**—Die Geschichte vom Hasen (1934)

GMs., in a black and white notebook, KSA

Schwitters's emphasis on transformation in his paintings and other writings is fully realized in this marvelous little tale.

**The Three Wishes**—Die drei Wünsche (1936)

MMs., KSA

This tale is similar to Schwitters's earlier tale "Happiness," in which three sisters are granted three choices. Here, too, the notion of happiness is in contradiction to the happiness of traditional fairy tales.

**The Ugly Young Woman: A Fairy Tale**—Das häßliche
Mädchen: Ein Märchen (1937)

Date: January 28, 1937

GMs., KSA

Schwitters was always critical of the artificiality of high society. He wrote this tale on paper bearing the letterhead of the Hotel Continental in Stockholm, and it may have been based on his experiences in Sweden before his flight from Germany.

**The Two Brothers**—Die beiden Brüder (1938)

GMs., KSA

This Cain and Abel tale is an obvious critique of the barbaric attitude of the Nazis toward their own tradition and land.

**The Fish and the Ship's Propeller**—Der Fisch
und die Schiffsschraube (1938)

Date: October 2, 1938

GMs., KSA

Schwitters draws a clear parallel in this tale to the conformity of the German people who looked to a dictator for their savior.

**Transformations**—Verwandlungen (1938)

Date: December 11, 1938

GMs., KSA

Similar to "The Story about the Rabbit," this tale is more philosophical but just as hilarious and nonsensical.

**He Who Is Mentally Retarded**—Der, der da geistig arm ist (1938)

MMs., KSA

The German text, which I have translated, is a translation by Kurt Schwitters's son, Ernst, based on a tale written in Norwegian by Schwitters. There is also an English translation of the Norwegian text called "The Idiot," completed in England in 1941 by Schwitters and Ernst.

In keeping with the folk tradition about wise fools, Schwitters's tale reveals that "idiots" are much smarter than people think. The influence of Schwitters's Norwegian exile is apparent.

**Hans and Grete: A Fairy Tale about Children Who Live in the Woods**—Hans und Grete: Märchen von Kindern, die im Walde wohnen (1939)

Date: Lysaker, November 16, 1939

HMs., KSA

There is a vague reference to the Grimms' tale of "Hansel and Gretel," but this story is more a serious reflection about the loss of ideals. Hans and Grete were typical German names in Schwitters's lifetime and might refer more to common young Germans in Nazi Germany than to the protagonists of the Grimms' tale.

**The Fairy Tale about Happiness**—Das Märchen vom Glück (1930–1940)

GMs., KSA

Schwitters did not finish this tale, but it clearly reflects his pessimism during the 1930s.

### Normal Insanity—Normaler Unsinn (1930–1940)

GMs., KSA

Schwitters did not fully develop this tale, but he was evidently endeavoring to comment on the normal insanity of Nazi Germany.

### What Is Happiness?—Was ist das Glück (1940–1945)

GMs., KSA

This tale is similar to "The Fairy Tale about Happiness," in which an angel flies to earth to find a happy person, but it is more complete and more pessimistic. Schwitters had more or less abandoned his faith in humanity during the early years in England.

### The Man with the Glass Nose—Der Mann mit dem gläsernen Nase (1945)

Date: October 23, 1945

MMs., KSA

Schwitters felt alienated in England and was apparently disappointed by the "politeness" of the English, who did not speak frankly to him. Nor did he receive much help with regard to his artistic work. Certainly, "The Man with the Glass Nose" might be considered an apt self-portrait.

*Schwitters's text reads: "Nein, Erich, wie wundervoll heute wieder Ihre Nase schillert. Sie sind ja der reine Schiller; denn wer Schiller heißt, der muß auch schillern können. " He plays with the name of the famous German poet Friedrich von Schiller. The verb *schillern* means to shimmer.

### Once upon a Time There Was a Tiny Mouse—
Es war einmal eine kleine Maus (1941–1946)

HMs., KSA

This tale is a delightful reversal of the typical fable about the cat and the mouse in a "dog-eat-dog" world.

### Tales Written in English

### The Flat and the Round Painter (1941)

The original title of this tale was "The Story of the Flat and Round Painter." It was translated from the German by Heinz Beran and copies were made to be distributed for the Germans who were interned at the British camp on the Isle of Man. Schwitters was also interned there from June 1940 to August 1941.

### London: A Fairy Tale (1942)

MMs., KSA

The fairy in this tale might be Schwitters's gentle and ironic characterization of Edith Thomas.

### The Flying Fish (1944)

Date: August 6, 1944

HMs., KSA

It seems that Schwitters did not finish this tale, but he apparently intended to deal ironically with the banality of the English couple and the adventurous spirit of the flying fish.

**Twopenny Novel about an Ugly Girl** (1941–1945)

MMs., KSA

The ironic comment on conventional romantic love recalls Schwitters's early more provocative poems. However, he seems to have come full circle with this tale and to be more optimistic about sentimental love.

# Bibliography

## Works by Kurt Schwitters

Schwitters, Kurt. *Das literarische Werk.* Ed. Friedhelm Lach. 5 vols. Cologne: DuMont, 1973–1981.

———. *Poems, Performance Pieces, Proses, Plays, Poetics.* Ed. and trans. Jerome Rothenberg and Pierre Joris. Philadelphia: Temple University Press, 1993.

———. *Wir spielen, bis uns der Tod abholt: Briefe aus fünf Jahrzehnten.* Ed. Ernst Nündel. Frankfurt am Main: Ullstein, 1974.

## Secondary Literature

Adorno, Theodor. *Aesthetic Theory.* Trans. and ed. Robert Hullot-Kentor. Minneapolis: University of Minnesota Press, 1997.

Burns Gamard, Elizabeth. *Kurt Schwitters' Merzbau: The Cathedral of Erotic Misery.* Princeton: Princeton Architectural Press, 2000.

Dietrich, Dorothea. *The Collages of Kurt Schwitters: Tradition and Innovation.* Cambridge: Cambridge University Press, 1993.

Elderfield, John. *Kurt Schwitters.* London: Thames and Hudson, 1985.

———. "Schwitters's Abstract Revolution." *German Life and Letters* 24 (1971): 256–61.

Gay, Peter. *Weimar Culture: The Outsider as Insider.* New York: Harper & Row, 1970.

Germundson, Curt. "Montage and Totality: Kurt Schwitters's Relationship to Tradition and Avant-garde." In *Dada Culture:*

*Critical Texts on the Avant-Garde*, ed. Dafydd Jones, 156–86.
Amsterdam: Rodopi, 2006.

*Kurt Schwitters*. Special Issue of *Text+Kritik* 35/36 (October 1972).

*Kurt Schwitters: Merz—ein Gesamtweltbild*. Bern: Bentelli, 2004.
Based on the exhibition at the Museum Tringuely, Basel, May
1–August 22, 2004.

Lach, Friedhelm. *Der Merz Künstler Kurt Schwitters*. Cologne: Du-
Mont, 1971.

————. "Sinn aus Unsinn—Uberlegungen zur Schwitters-Interpre-
tation." In *Sinn aus Unsinn: Dada International*, ed. Wolfgang
Paulsen and Helmut Hermann, 177–92. Bern: Francke, 1982.

Mansoor, Jaleh. "Kurt Schwitters' Merzbau: The Desiring House."
*Invisible Culture: An Electronic Journal for Visual Culture* 4
(2002): 1–12.

Martakies, Robin. *Kurt Schwitters: Free Spirit*. Victoria, Canada:
Trafford, 2006.

McBride, Patrizia. "The Game of Meaning: Collage, Montage, and
Parody in Kurt Schwitters's Merz." *Modernism/Modernity* 14.2
(April 2007): 249–72.

McLain, Meredith. "Merz, ein Weg zum Wissen. Relativität und
Komplimentarität in Kurt Schwitters' Weltanschauung." In
*Sinn aus Unsinn: Dada International*, ed. Wolfgang Paulsen
and Helmut Hermann, 193–210. Bern: Francke, 1982.

Meyer-Büser, Susanne, and Karin Orchard, eds. *In the Beginning
Was Merz: From Kurt Schwitters to the Present Day*. Ostfildern
Ruit: Hatje Cantz, 2000.

Nündel, Ernst. *Kurt Schwitters*. Reinbek bei Hamburg: Rowohlt,
1981.

Paulsen, Wolfgang, and Helmut Hermann, eds. *Sinn aus Unsinn: Dada International*. Bern: Francke, 1982.

Reitz, Leonard. "Schwitters and the Literary Tradition." *German Life and Letters* 27 (1974): 303–15.

Richter, Hans. *Dada Art and Anti-Art*. Trans. David Britt. London: Thames and Hudson, 1965.

Schmalenbach, Werner. *Kurt Schwitters*. Cologne: DuMont, 1967.

Shaffer, E. S. "Kurt Schwitters, Merzkünstler Art and Word-Art." *Word & Image* 6.1 (April–June 1990): 100–118.

Steinitz, Kate Trauman. *Kurt Schwitters: A Portrait from Life*. Berkeley: University of California Press, 1968.

Webster, Gwendolen. "Kurt Schwitters and Katherine Dreier." *German Life and Letters* 52.4 (1999): 443–56.

——. *Kurz Merz Schwitters: A Biographical Study*. Cardiff: University of Cardiff, 1997.

Weitz, Eric. *Weimar Germany: Promise and Tragedy*. Princeton: Princeton University Press, 2007.

West, Shearer. *The Visual Arts in Germany, 1890–1937: Utopia and Despair*. New Brunswick, N.J.: Rutgers University Press, 2001.

Zipes, Jack, ed. *Fairy Tales and Fables from Weimar Days*. Hanover, N.H.: University Press of New England, 1989.

CPSIA information can be obtained
at www.ICGtesting.com
Printed in the USA
LVOW08s0820080617
537103LV00008B/4/P